KITTY HAWK
And Beyond

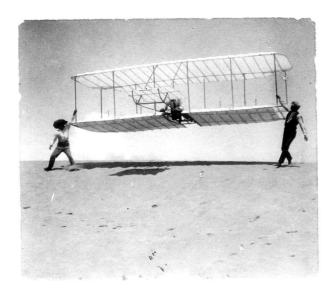

KITTY HAWK

AND BEYOND

The Wright Brothers and the Early Years of Aviation
A Photographic History

Ronald R. Geibert
and
Patrick B. Nolan

WRIGHT STATE UNIVERSITY PRESS
Dayton, Ohio

Copyright © 1990 by Wright State University Press
Wright State University
Dayton, OH 45345

All Rights Reserved

Printed in the United States of America

British Cataloging in Publication Information Available

Distributed by arrangement with
University Publishing Associates, Inc.

4720 Boston Way
Lanham, MD 20706

3 Henrietta Street
London WC2E 8LU England

49899

Library of Congress Cataloging-in-Publication Data

Geibert, Ron.
Kitty Hawk and beyond : the Wright Brothers and the early
years of aviation : a photographic history / by Ronald R.
Geibert and Patrick B. Nolan.
p. cm.
ISBN 0-929090-01-2
1. Wright, Orville, 1871-1948. 2. Wright, Wilbur, 1867-1912. 3.
Aeronautics–United States–Biography.
4. Aeronautics–United States–History–Pictorial works. I.
Nolan, Patrick B. (Patrick Bates). 1942- . II. Title.
TL540.W7G45 1989
629.13'0092'2–dc20
[B] 89-16744
CIP

This book was designed by Bert Smith and produced by
him and Sally Barba under the auspices of the Institute for
Publications Design at the University of Baltimore. The
typeface is Century Old Style, set in WordPerfect 5.0 loaded
into Ventura Publisher 2.0 page layout, and printed out on a
Linotronic 200, with display capitals in an early wood type
version of Comstock.

CONTENTS

FOREWORD
vii

INTRODUCTION
xi

ACKNOWLEDGEMENTS
xv

BEFORE FLIGHT
1

KITTY HAWK
19

EUROPE AND AMERICA
65

FLYING BECOMES A BUSINESS
123

THE LONG TWILIGHT
151

ABOUT THE AUTHORS
160

FOREWORD

N owhere is the truth of the adage "a picture is worth a thousands words" more apparent than in the story of the invention of the airplane. Seldom, if ever, has a technological breakthrough so stunned the world. The notion that a human being might actually take to the sky aboard a machine many times heavier than the odorless, colorless, apparently insubstantial atmosphere supporting it seemed to violate common sense.

"Flight was looked upon as an impossibility," Orville Wright explained, "and scarcely anyone believed in it, until he actually saw it with his own eyes." But see it they did. By 1908 newspapers and magazines around the globe were filled with pictures of the intrepid birdmen and their flying machines. The spectacular photographs of airplanes in flight laid to rest any lingering doubts about the arrival of the air age.

From the outset, Wilbur and Orville Wright had recognized the important role that photography could play in documenting their work. They took their own pictures during the key years, 1900-1905, and did a first-rate job of it. The 303 glass plate nega-

tives surviving from that period represent a priceless visual record of their experiments, from a single picture of the less than satisfactory 1900 glider being flown as a kite, to stunning photographs of the world's first practical airplane in full flight over a Dayton, Ohio, cow pasture in the high summer of 1905.

In the process, the Wrights produced a number of images that can only be regarded as masterpieces of the photographer's art. Try looking at the pictures of the 1902 glider in the air while seated in an easy chair some quiet evening. You can almost feel the sting of the Outer Banks sand and salt air against your face and hear the sound of the wind rushing through the wires and over the fabric of the wings.

Then, of course, there is *the* picture, perhaps the best known and most reproduced photograph ever taken. It is a split second in time, frozen on a fragile glass plate measuring five by seven inches. John T. Daniels, a local man who had stopped by the Wright's Kill Devil Hills, North Carolina camp to lend a hand, snapped the shutter at 10:35 on the morning of December 17, 1903.

He caught Wilbur in mid-stride, his suit coat billowing in the 20-mile-per-hour wind, as Orville coaxed the 1903 airplane aloft for the first time. This single image has enable millions of people around the globe to share a special sense of the drama, tension, and sheer excitement of an extraordinary moment in history.

The Wrights stepped onto the world stage with their first public flights in the late summer and fall of 1908. Photographers swarmed to Le Mans and Pau, France, Fort Myer, Virginia, Rome, Berlin, Governor's Island, New York, and the other places where the brothers took to the air, eager to record the miracle of flight on film.

By nature very private men, the Wrights were uncomfortable in their new role as public figures. Newsmen and photographers occasionally pushed them too far. Such was the case on June 19, 1909, when Wilbur discovered a photographer snapping pictures following a minor crash that occurred during trial flights at Fort Myer, to satisfy the term of an army contract. Unable to control his anger, he picked up a piece of wood and threw it at the fellow, then demanded the exposed plates. He had done the same thing in France in 1908, vaulting a low fence to confront a man taking unauthorized pictures of a Wright airplane being prepared for takeoff.

But there was to be no escape from the glare of publicity. The Wrights were the first great heroes of the new century, and the public could not get enough of them. Pictures of Wilbur, Orville, and their sister Katharine appeared time and again on the front pages of the world's newspapers. A thousand clicking shutters caught them climbing aboard their airplanes, rubbing elbows with European royalty, accepting awards, and simply walking down the street.

These photographs, preserved today in libraries, archives, and museums, are a precious historical resource. The technical details of the Wright achievement are recorded in crystal clear, high-resolution prints made from the original glass plate negatives. Surviving news photos and snapshots provide a unique window into the past for historians who seek to better understand the two famous brothers and their era.

As a young graduate student, I spent

part of the summer of 1973 immersed in the great collections of Wright papers and photographs housed at the Library of Congress and the Smithsonian's National Air and Space Museum. The late Marvin W. McFarland, then chief of the Division of Science and Technology at the Library of Congress, suggested that the answers to at least some of my questions might be found in an additional cache of Wright material still in private hands in Dayton, Ohio.

His comment took me by surprise. A native of Dayton, thoroughly familiar with the small collections of Wright items at the local library and historical society, I assumed that virtually everything of interest to a Wright scholar had long since gravitated to the great institutions in the nation's capital. I had much to learn.

Armed with an introduction from Mr. McFarland, I presented myself at the home of Mr. and Mrs. Harold S. Miller a few weeks later. For a student of the early history of flight, it was something of an occasion. Mrs. Miller was a favorite niece of the Wright brothers. Mr. Miller had been the co-executor of Orville's estate. Neatly boxed,

stacked, and shelved away in the Miller's basement were books from the Wright brother's library, original family papers, financial records, and thousands of photographs — a mine of new information about the brothers and their family.

Within an hour, I found the answer to the specific question that brought me there. It was right where Mac McFarland thought it might be — in a handwritten note that Wilbur had penned in the margin of an old aeronautical journal. The rest of the day was spent sorting through box after box of historical treasure. Late that afternoon, over a glass of milk and a plate of cookies, I asked the Millers why this wealth of material had not gone to the Library of Congress with the bulk of the Wright papers in 1949.

They explained that the library staff had been very selective, taking only those items directly related to the invention and development of the airplane, along with the correspondence of Milton, Wilbur, Orville, and Katharine Wright, and a relatively narrow range of additional materials. Family genealogical records, items relating to Bishop Milton Wright's career, even the

school records of the Wright children, were not included in the Library of Congress collection. Books and papers that duplicated library holdings, some of them annotated by the Wrights, were left behind. The library accepted the original Wright glass plate negatives, but not the roughly three thousand photographic prints in the Wrights' personal collection.

Mr. and Mrs. Miller remarked that they were looking for a permanent home for the material. Primarily, I think, as a kindness to me, they paid a visit to the Manuscript Division of the Ohio Historical Society, where I was then employed while completing work on a doctorate at Ohio State University. It was clear, however, that they preferred a repository in the Dayton area, where the Wright brothers had lived and worked. On December 19, 1975, they presented the collection to Wright State University, the youngest member of Ohio's system of state-supported universities.

It was a wise decision. University archivist Patrick Nolan and his staff went to work immediately, arranging and cataloging the material, and publishing a superb guide to the collection. Since that time, the Wright Brothers Collection has become a magnet attracting other important materials on the early history of flight to the Wright State University Archives. Several years ago, Wright State staff members, including the authors of this book, produced a major traveling exhibition of original photographic prints drawn from the collection. That exhibition is still receiving accolades as it tours the nation.

Now Ronald Geibert and Patrick Nolan have gathered some of the photographic gems of the Wright Brothers Collection into the book that you hold in your hands. Here is the story of an extraordinary American family, told in text and marvelous pictures. *Kitty Hawk and Beyond: The Wright Brothers and the Early Years of Aviation, a Photographic History* is the closest thing you will find to a Wright family photo album.

TOM D. CROUCH, CHAIRMAN,
DEPARTMENT OF AERONAUTICS
NATIONAL AIR AND SPACE MUSEUM
SMITHSONIAN INSTITUTION
WASHINGTON, D. C.

INTRODUCTION

—◆—

One can imagine the collective "click" from the thousands of Kodak Brownies, Folding Pocket cameras, and German "Klapp" cameras that were pointed every time Orville Wright piloted his Flyer into the Berlin sky of 1909. Each photographer was hoping to produce irreproachable evidence of the incredible sight he was witnessing. The event was all the more remarkable considering that some scientific experts of the period had decreed manned flight an impossibility, and certain clergy had preached that such a desire was blasphemous. In their minds, flying was one skill reserved for the angels. *Kitty Hawk and Beyond* is a photographic diary of two God-fearing people in pursuit of that "angelic skill."

When did mankind first look to the birds and angels with envy? The story of Icarus suggests that very early mankind literally plunged into the uncharted waters of flying. Since that fateful tumble, the skeptical and the gullible had been entertained by people claiming to have solved the "flying problem." Fortunately, during the twentieth century most of the epochal episodes of flight have been documented by photographs. Indelibly imprinted on our minds are the triumphs and failures: a youthful-looking Lindbergh, the collapsing and burning *Hindenberg,* Earth as seen from a moon-orbiting *Apollo* spacecraft, the ominous corkscrew exhaust of the *Challenger's* booster rockets — and the universally familiar "First Flight" by Wilbur and Orville Wright at Kitty Hawk, North Carolina, in 1903 — among others.

These photographs have provided far more than data for the trained scientific eye. They have, in fact, fashioned our dream of flight itself. This shaping power is probably most captivating in the collection of photographs that belonged to Wilbur and Orville Wright. What separates this particular collection from others, besides its obvious historical significance? How did it come into being?

Wilbur and Orville Wright came to photography as self-taught practitioners. They used the camera into the late 1890s to photograph their family and home, the bicycle shop they owned, and local children and events. Although advances in camera

design at the time were putting convenient "snapshot" cameras with flexible roll film into the hands of millions, Wilbur and Orville continued to use wooden view cameras mounted on tripods. The slow, cumbersome instruments imposed physical and technical demands in the field, but the dry glass plate negatives yielded an image of higher resolution. Over the course of a decade the brothers made hundreds of exposures, using first a four-by-five-inch camera and next a five-by-seven Korona before finally adopting a hand-held German-designed Goertz.

Many flight enthusiasts contracted with photographers to record important undertakings or attempted to made their own snaps. But the Wrights' involvement with photography before their flight experimentation gave them a decided advantage in documenting their progress and paid rich dividends. Where others would casually point their cameras, the Wrights often searched out a vantage point or selected a particular moment for exposing the negative providing a better sense of light, space, scale, and motion. In other words, theirs

were photographs with expressive and poetic qualities. The intimacy and directness of plate 17, the harmony of motion and form found in plates 20, 21, and 30, and the compositional excitement shown in plates 32 and 35 illustrate particularly well a refinement and quality that are generally missing from the photography of their competitors. This is not to suggest that the Wrights were artists, for their body of work lacks a consistent vision and technical proficiency. One can certainly draw the conclusion, though, that as engineers they had an uncharacteristic interest in how their pictures looked.

When Wilbur and Orville began their demonstrations abroad, they often found themselves on opposite sides of the Atlantic Ocean. They therefore had to rely on others to photograph their activities. And photograph they did! The prints from amateurs and professionals in the United States and Europe reproduced in this book provide not only a record of the Wrights' activities, but also a fascinating overview of the state of photographic technology and vision of the time. The prevalent hand cameras and the public's interest in "captur-

ing a piece of life" on film opened a new photographic repertoire: spontaneity, truncated bodies, unconventional viewpoints, and gestural energy, for example. Although often crude in execution, these photographs exhibited freshness and visual richness. Adding these donated prints to their own collection of photographs, the Wrights increased the total to nearly thirty-five hundred. This collection remained at the Wrights' Dayton laboratory until Orvilles' death in 1948, when the material was transferred to the home of Mrs. Ivonette Wright Miller, daughter of Wilbur and Orville's brother Lorin.

In 1975 some private papers and Wilbur and Orville's personal collection of photographs were given by the Wright heirs to Wright State University, located in their hometown of Dayton. The acquisition was cataloged under the direction of University Archives director and historian Patrick Nolan; and he and John A. Zamonski wrote a guide to the collection (*The Wright Brothers Collection: A Guide to the Technical, Business and Legal, Genealogical, Photographic, and Other Archives at Wright State University*).

The photographic collection received international attention in 1984-87, when Tucker Malishenko and Ronald Geibert organized an exhibition of selected prints for tour by the Smithsonian Institution in Washington, D. C. The exhibition, *Early Flight: 1900-1911,* was accompanied by a book of the same title, with Geibert's text providing the first critical analysis of the Wright brothers as photographers and of the role that photography played in their research activities.

Selecting images and text for *Kitty Hawk and Beyond* has been a fascinating but at times difficult undertaking. Unfortunately, the Wrights' darkroom expertise was often sadly lacking. Using a darkroom located in a shed behind their home, they processed much of their work improperly, producing prints now faded and discolored in varying degrees. Especially in the early years (1900-1901), the brothers tended to crop and recrop photographs until they measured but a few square inches. This created a serious problem for us. Making new prints from the original negatives

housed at the Library of Congress was not an option. A significant number of the negatives were seriously damaged from having been submerged during the Dayton flood of 1913. Wear and tear during the past eighty to ninety years made many of the other negatives virtually useless. In addition, the delicate nature and unevenness of the original rare prints at the Wright State Archives made their use by the printers questionable. Therefore, we elected to have copy negatives made of the original prints and to produce custom prints. This gave us an opportunity to improve many images with darkroom manipulation (changing the contrast, lightening or darkening the print) and yet retain the integrity of the image.

We made our final selection of photographs and artifacts by weighing their historical, informational, and aesthetic values. In most cases we accompanied the material with Wilbur and Orville's own words, to humanize these two mythic people and preserve the colloquialisms and flavor of the period. The plates are in chronological sequence and, unless otherwise credited, from the Wright State University Archives and Special Collections. The images touch on many aspects of the Wrights' lives. We view it as the "family photo album" that Wilbur and Orville were never privileged to make. We hope we have done Wilbur and Orville justice.

RONALD E. GEIBERT
PATRICK B. NOLAN

ACKNOWLEDGEMENTS

We offer our thanks for the generous support provided by the office of the vice president for academic affairs and the College of Liberal Arts at Wright State University in Dayton, Ohio. Additional funding was donated by the Friends of the WSU Library, a group that more than once has helped preserve Dayton's rich aviation history. Special thanks must certainly go to the dedicated staff of the University Archives. And finally, we appreciate the support and suggestions given by our patient wives.

RONALD R. GEIBERT
PATRICK B. NOLAN

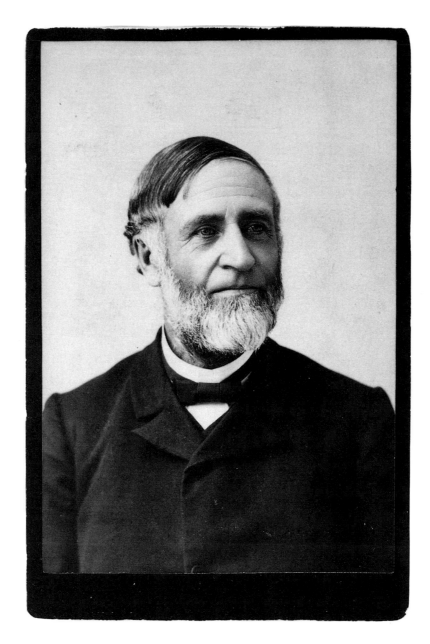

Plate 1. BISHOP MILTON WRIGHT

Father of Wilbur and Orville Wright (November 17, 1828-April 3, 1917).

Hollnger's Mamoth [sic] Photograph Gallery, Dayton, Ohio

BEFORE FLIGHT

———————◆———————

NOTHING IN THE FAMILY BACK-
ground and ancestry of Wilbur and Orville Wright gave their contemporaries reason
to expect greatness of them. Their parents came from solid, respectable, God-fearing
midwestern stock, and none of their ancestors had made any particular mark on
history. The traits of genius that permitted the Wright brothers to solve the "flying
problem" appeared unpredictably and, as is often the case with genius, almost ran-
domly and without warning.

Milton Wright, their father, was born on November 17, 1828, on a farm in
Rush County, Indiana. The son of Dan Wright and Margaret Van Cleve, Milton grew
up in a religious household. Dan, an early settler near Dayton, Ohio, had "gotten
religion" during one of the periodic revivals in the region and had later moved to
Indiana and taken up farming. Milton, who was reared in a log cabin, was eighteen
when he, too, experienced a religious conversion and felt salvation. He joined the
Church of the United Brethren in Christ, a nonconformist Protestant sect with its
greatest membership strength in the rural districts of the Midwest, where it had
flourished since 1800.

Milton, who had been educated in Indiana country schools, attended
Hartsville College, a United Brethren institution also in Indiana, but had to cease his
formal schooling when the money ran out. Despite his little formal education and lack
of divinity degree, he received a license to preach from the United Brethren Church
in 1853 and was formally ordained a minister in 1856. The next year, he embarked on
his great adventure. Following the route of the forty-niners, the California gold-
seekers of a few years earlier, Milton headed west. By ship and mule he reached the

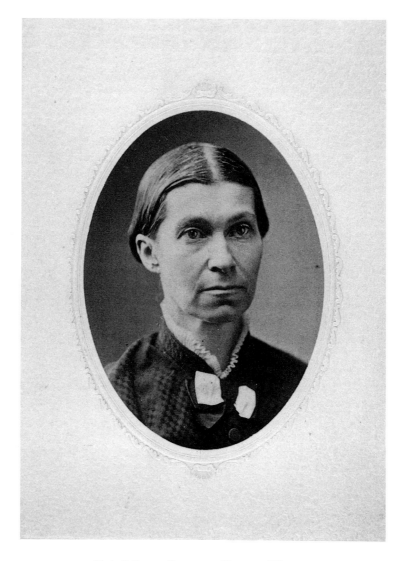

Plate 2. SUSAN CATHERINE KOERNER WRIGHT

Mother of Wilbur and Orville Wright (April 30, 1831-July 4, 1889),
she took an active interest in her husband's church activities and, referring to one of his
critics, she wrote in a June 1, 1888, letter to her husband:
"I have it in my mind to write him a note thanking him for the interest he has taken in your
welfare and that of your district and suggest that
Judas also took quite an interest in his Lord."

Bradley Artist and Photo, Dayton

Pacific Coast, stopped briefly at wicked San Francisco, and eventually ended up in the Willamette Valley of Oregon. There for two years he lived the life on an itinerant preacher and traveling missionary of the UB Church. Constantly on the move, dependent on the hospitality of strangers and church members, the Reverend Milton Wright preached the gospel on the unchurched Oregon frontier. For a time he served as principal of a small denominational school, Sublimity College.

From all the evidence, Milton enjoyed his adventurous career on the frontier, but the pay was virtually nonexistent, his health suffered, and he missed his family and sweetheart back in the Midwest. After two years he returned to Ohio, and there, on November 24, 1859, he married Susan Catherine Koerner, a woman he had met while they were both students at Hartsville College.

Susan, the daughter of German-born wagonmaker and wheelwright John G. Koerner, was born in Hillsboro, Virginia, on the eastern slope of the Blue Ridge Mountains. After marrying Milton, she spent the next twenty-five years frequently moving as Rev. Milton Wright's church duties took the growing family to various locations in Indiana, Iowa, and Ohio. Eventually there were five Wright children: Reuchlin (1861), Lorin (1862), Wilbur (April 16, 1867), Orville (August 19, 1871), and the only daughter, Katharine (1874).

Milton's career advanced in the church, and, though money was always short as he eked out a living by teaching and farming, his influence grew. He was elected and reelected bishop, became the editor of the *Religious Telescope* (the denominational organ) and the *Richmond Star,* and a presiding elder. Then in 1889 his unbending devotion to principle resulted in crisis. The Church of the United Brethren

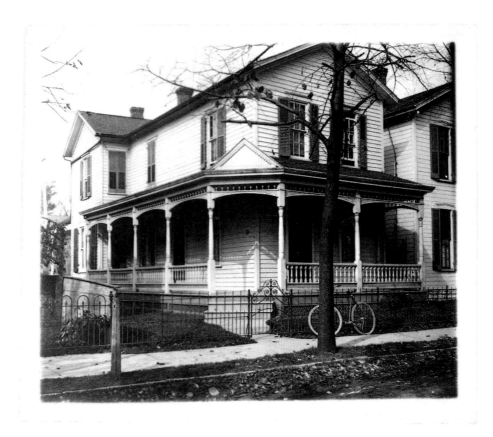

Plate 3. The Wright Family Home, 7 Hawthorn Street, Dayton, ca. 1895

Bishop Milton Wright purchased this house in April 1871, two years after he moved to Dayton to become editor of the *Religious Telescope*. The family lived in the house until April 28, 1914, when Orville, Katharine, and the bishop moved into a newly constructed mansion, Hawthorn Hill.

Wright photograph

in Christ had long prohibited members from joining secret societies such as the Masons, holding such memberships to be a violation of Christ's teachings. Beginning in 1889 and lasting until 1896. a schism developed between a liberal faction calling for a relaxation of the ban and conservatives, led by Bishop Milton Wright. The quarrel split the church, lawsuits ensued, disputes arouse over ownership of church property and assets, and Milton was embroiled in controversy. Eventually the conservative group was upheld in court, but Milton and his followers found themselves leaders of a much diminished flock.

Following hard on the heels of the "great schism" came the "Keiter affair." Starting in 1893 and not resolved until 1905, the dispute pulled the bishop into its vortex. A scandal developed over the management of the church publishing house in Dayton by its agent, Millard F. Keiter. Milton, with other church leaders, began to suspect that the books were not being properly kept. Audits uncovered large discrepancies, and Keiter was forced out of office. His friends and supporters attacked Milton and Milton's party, numerous lawsuits ensued, and not until 1905 could the bishop retire from active church management with his bishopric and dignity intact.

From their father, the bishop, Wilbur and Orville appear to have received two important traits that marked their subsequent careers. One was an unbending, almost obstinate devotion to principle or a course of action perceived as correct, regardless of opposition or obstacles. The same stubborn righteousness that carried Milton through the great schism and the Keiter affair would be evident when his sons pursued their patent litigation against Glenn Curtiss and the other infringers on the Wright patent.

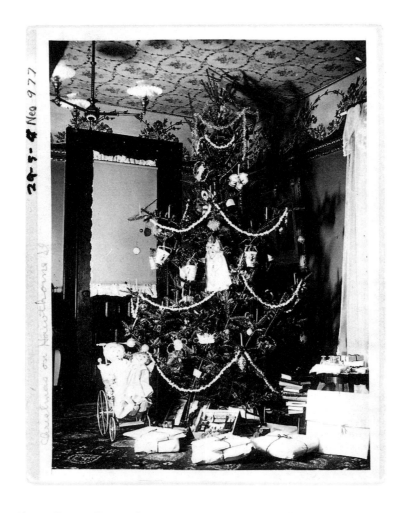

Plate 4. WRIGHT FAMILY CHRISTMAS TREE, 7 HAWTHORN STREET, DAYTON, 1897

Wright Photograph

The other trait was perhaps more appealing. It was intellectual openness and curiosity, a willingness to engage in scientific and humanistic inquiry, a delight in intellectual speculation, a fondness for reading. The bishop's library contained not merely works of theology and religion, but also a wide-ranging collection of history books, novels, encyclopedias, scientific treatises, and even the writings of the well-known agnostic Robert Ingersoll.

Susan Koerner Wright's contribution to the gene pool that produced the Wright brothers appears to have been a fondness for experimentation, mechanical aptitude, and a familiarity with tools, perhaps inherited from her cabinet- and wagon-making father. Susan certainly had a resourceful personality. During the bishops's frequent absences on business, Susan ran the household. To her children it seemed that she could make or repair anything. She repaired household utensils, devised useful appliances and ingenious toys, and built a sled for Reuchlin and Lorin.

By 1884 the Wright family settled permanently in Dayton, Ohio. The bishop purchased a house at 7 Hawthorn Street that was to remain the family home until 1914 when Orville, Katharine, and the bishop moved into a newly constructed mansion called Hawthorn Hill. The West Side of Dayton, where 7 Hawthorn Street stood, is located across the Great Miami River from the downtown area. Although close to center city, the river offered a psychological as well as a physical barricade for the district. The West Side had a clear-cut identity, with a self-sufficiency that supported many local businesses and services. The later business career of the Wright brothers would be rooted in the West Side, serving a neighborhood clientele and responding to local interests and concerns.

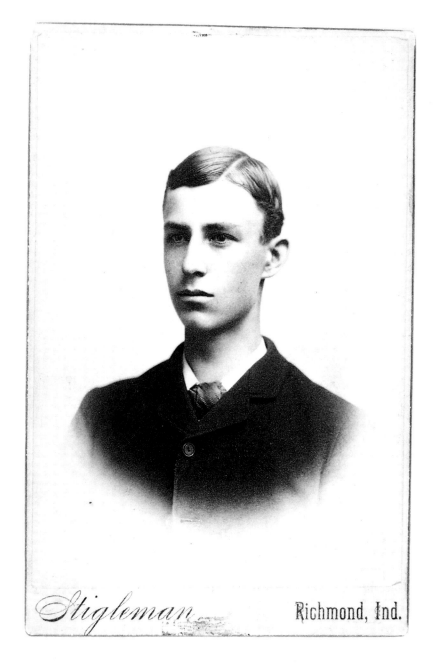

Plate 5.

WILBUR WRIGHT, AGE 17,
RICHMOND, INDIANA,
HIGH SCHOOL CLASS OF 1884

"I do not think I am especially fitted for
success in any commercial pursuit. . . . I
might make a living but I doubt whether I
would ever do much more than this.
Intellectual effort is a pleasure to me and I
think I would be better fitted for
reasonable success in some of the
professions than in business. I have always
thought I would like to be a teacher."
Wilbur Wright to
Milton Wright,
September 12, 1894.

Stigleman photograph,
Richmond, Indiana

8

Wilbur graduated from high school in Richmond, Indiana, the year the family returned to Dayton, but he declined to travel back to Indiana to receive his diploma. He took post high school courses in Greek and trigonometry and contemplated going to college. Then he was diverted from his course. While playing a pickup game of ice hockey, he was smashed in the face with a hockey stick, losing several teeth and undergoing reconstructive surgery. He spent the next four years in a sort of limbo. Afflicted with a vaguely defined "heart disorder." self-conscious about his appearance after the accident, Wilbur became almost a recluse, seldom leaving the house, reading, daydreaming, and idly thinking. In addition, his mother needed his attention. Susan, suffering from consumption, was in steadily declining health, and Wilbur provided her nursing care. The two semi-invalids remained housebound until Susan's death in 1889 at the age of fifty-eight.

It was Orville who drew Will out of his isolation and depression. "Orv," always the gregarious tinkerer, had become interested in printing. While in high school, he and a friend, Ed Sines, built a printing press and began publishing a small tattle-sheet paper. Paul Laurence Dunbar, later to be a poet, was a classmate of Orville's, and his work first appeared in print in Orville's little paper. By 1889 the *West Side News* was a full-fledged weekly, Wilbur had joined the business, and Wright & Wright, Printers, was a going concern. In 1890 the boys tried publishing a daily paper, *The Evening Item*, but patronage did not support it for more than a few months. Job printing was the bread and butter of the enterprise, and a host of advertisements, brochures, pamphlets, reports, and other print jobs rolled off the Wright presses.

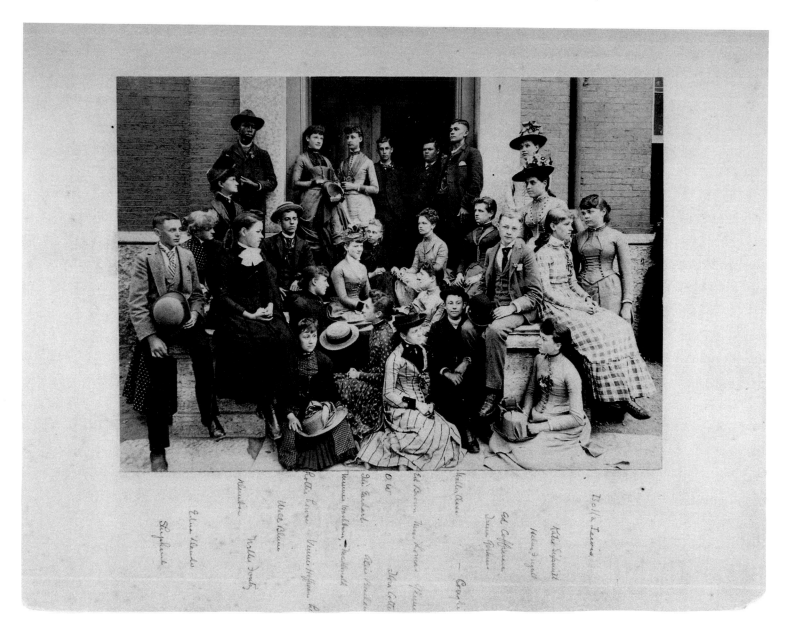

Plate 6. ORVILLE WRIGHT, AGE 18, AND PAUL LAURENCE DUNBAR, DAYTON CENTRAL HIGH SCHOOL CLASS OF 1890

Last on left, top row, Dunbar; fourth from left, top row, Orville. "Paul Laurence Dunbar, the negro poet,
and I were close friends in our school days and in the years immediately following. When he
was eighteen and I nineteen, we published a five-column weekly paper for people of his race; i.e., we
published it as long as our financial resources permitted of it, which was not for long!"
Orville Wright to Edward Johnson, January 2, 1934. *Photographer unknown*

Although printing was a solid trade, it gave the young men little room for real business expansion. By the 1890s, a new phenomenon, the safety bicycle, had appeared on the American scene. The bicycle was the first cheap and readily available form of personal transit, and cycling became a craze. The Wrights had a knack for adapting careers to changing circumstances. In 1892 the bishop's boys shifted their energies to this new endeavor.

They rented the first of what was to be a series of shops on the West Side and founded the Wright Cycle Company. At first limiting themselves to selling and repairing commercially available brands, by 1896 the Wrights were manufacturers as well. The St. Clair, Van Cleve, and Wright Special were soon rolling out of the shop and into the hands of willing customers. Business became so brisk that printing activities faded from their minds and cycling dominated the brothers' lives.

Wilbur and Orville could have settled down to quiet lives as middle-class, middle western small businessmen, yet something seemed to nag at them; something urged them to embark on an intellectual odyssey with a challenge greater than that of selling bicycles. A family story traces their fascination with flight to a childhood incident when the bishop, returning from one of his long church trips, brought the young boys a rubber band powered toy helicopter that flew around the room, with the excited youngsters in hot pursuit. Maybe so. We do know that they followed with interest the sensational hang glider flights of the intrepid German Otto Lilienthal. The reports of his tragic death in a glider crash in 1896, widely disseminated in the press, led the boys to a more systematic and concentrated focus on the "flying problem."

Although both Wilbur
and Orville were good
students, neither
formally graduated from
high school. Wilbur
completed his senior
year in Richmond,
Indiana, but when the
family moved to Dayton
in June 1884, he
declined to return to
Richmond to graduate
and collect his diploma.
Orville entered Dayton's
Central High School as a
senior in 1890 but
dropped out before
graduation to
concentrate on the
printing business.
Interestingly, this report
card exhibits mud stains
as a result of
submersion during the
Dayton flood of 1913. A
teacher noted on the
back that Wilbur had the
"highest percent
in his room."

Dayton Public Schools.

QUARTERLY REPORT.

Seventh District, _____ 1877

Mr. Wright

Dear Sir:

Your attention is most respectfully invited
to the following record made by

Wilbur _____ in the Examination held

_____ 1877

SUBJECTS EXAMINED.

PER CT.		PER CT.	
Reading,	81	Arithmetic,	100
Spelling,	88	Grammar,	96
Writing,	93	Geography,	92
Composition,	95	U. S. History,	
Definitions 105		Men. Arith. 100	
Music 100			

No. Half Days Absent _____ Average 74.5 per ct.

No. Times Tardy _____ Deportment excellent

Average per ct. of Class 77

The Maximum per cent. is 100.

_____ Teacher.

Spring still makes spring in the mind,
 When sixty years are told;
Love wakes anew the throbbing heart,
 And we are never old.

Over the winter glaciers
 I see the summer glow,
And through the wild-piled snowdrift,
 The warm rosebuds below.

—*Emerson.*

Name...... *Willow*

Date......

Position...... *Alternate axilary spiral lateral appressed*

Size...... *½ to ⅓ in length ⅛ to ¼ in thick ness*

Form...... *long pointed at both ends somewhat flat*

Color...... *Green Brown*

Protective Elements...... *Scales and fuzz many scales*

Peculiarity...... *Has a peculiar blossom*

Leaf Scars......

Cross-section of Branch. Cross-section of Bud.

Drawing of Branch.

III

Plate 8.

A BOTANICAL DRAWING BY ORVILLE WRIGHT, 1887

Orville's scientific curiosity is illustrated by this carefully made drawing in his botanical notebook.

Plate 9. YMCA ANNOUNCEMENT, WRIGHT AND WRIGHT PRINTERS

"Will and I have been quite busy for a few days printing a 'job' We had not enough type to print it all at once so we had to run it through the press twice, making it a very difficult job. . . . The work we can do on this press is much better than that done on the old one. The new press works in an entirely new way." Orville Wright to Milton Wright, July 20, 1888.

Plate 10. WOODCUT, WRIGHT AND WRIGHT PRINTERS, 1888

As part of their printing venture, Wilbur and Orville reproduced this woodcut drawing
by their brother Lorin. During the creation of "A Summer Traveler,"
Lorin's "tool slipped and nearly took his jugular."

Whatever the source of their interest, the Wrights began to read works on bird flight and mechanical and human flight. By 1899 they had initiated correspondence with the Smithsonian Institution in Washington, D.C., assembled an impressive reading list, and begun writing to leading aviation authorities, most importantly Octave Chanute, who would remain one of their staunchest supporters. The stage was set for the Wrights' epoch-making work on the airplane.

Wilbur Wright
Orville Wright

Manufacturers of
Van Cleve
Bicycles
St. Clair

Established in 1892.

Wright Cycle Company

1127 West Third Street.

DAYTON. OHIO. Sept. 3. 1900

Dear Father:

I received a letter from Reuchlin some days ago making inquiry about several matters relating to the farm concerning which I knew nothing. He wished to know how many acres there are of grass and hay land, and whether the buildings have any insurance on them. He also wished to know when the renters year is supposed to end, and when the rent on meddow is due.

I am intending to start in a few day for a trip to the coast of North Carolina in the vicinity of Roanoke Island, for the purpose of making some experiments with a flying machine. It is my belief that flight is possible and while I am taking up the investigation for pleasure rather than profit, I think there is a slight possibility of achieving fame and fortune from it. It is almost the only great problem which has not been pursued by a multitude of investigators, and therefore carried carried to a point where further progress is very difficult. I am certain I can reach a point much in advance of any previous workers in this field even if complete success is not attained just at present. At any rate I shall have an outing of several weeks and see a part of the world I have never before visited.

affectionately your son

KITTY HAWK

———◆———

AS THEY STOOD ON THE THRESH-
old of their great work in aeronautical research, Wilbur and Orville Wright presented
contrasts and similarities to the casual observer. Physically, they did not much
resemble each other. Wilbur stood almost five feet ten inches tall and weighed a bit
less than 140 pounds. His sparse, angular, bony body made him appear much taller
and thinner. He had begun losing his hair while still in high school and by now was
almost bald, with a high, domed forehead. Many reporters remarked on his lean face,
strong features and "hawk-like" visage. His eyes were particularly noticeable, keen
and observant with "an ardent flame," "a superb blue-grey, with tints of gold."

Orville, by contrast, was more conventionally handsome. He kept his hair
longer than Wilbur's and had worn a mustache since adolescence. A bit shorter and
a few pounds heavier than his brother, Orville was by far the better dresser, more
conscious of his appearance and neater and more particular about his clothes. His
family often commented on his seeming ability to work for hours with dirty, greasy
machines and yet appear unspotted and neatly groomed. Both brothers adhered to a
strict dress code. Even on the sands of Kitty Hawk, working in all weathers in an almost
wilderness setting, they wore white shirts, stiff collars, vests, and suitcoats.

They differed also in personalities. Orville was the more excitable, impul-
sive, and enthusiastic of the two. When their research became difficult and discourag-
ing, Orv supplied the optimistic boost to keep going. He seemed a natural inventor,
always trying out new gadgets and devices, tinkering with improvements. He also
became the better pilot of the pair, showing a greater aptitude for flight.

Wilbur, by contrast, seemed more the scholar. Reflective, given to long silen-
ces and deep thought, he appeared a natural scientist. A voracious reader, he excelled

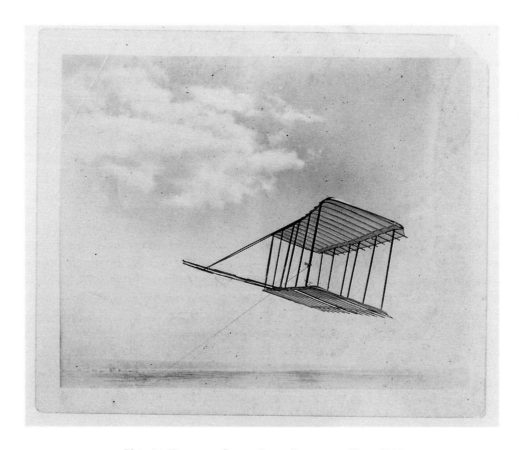

Plate 14. TETHERED GLIDER BEING FLOWN AS A KITE, 1900

"For some years I have been afflicted with the belief that flight is possible to man. My disease has increased in severity and I feel it will soon cost me an increased amount of money if not my life. I have been trying to arrange my affairs in such a way that I can devote my entire time for a few months to experiment in this field. It is possible to fly without motors, but not without knowledge and skill. This I conceive to be fortunate, for man, by reason of his greater intellect, can more reasonably hope to equal birds in knowledge, than to equal nature in the perfection of her machinery."
Wilbur Wright to Octave Chanute, May 13, 1900.

Wright Photograph

at analyzing complicated ideas, dissecting a problem into its component parts, and translating his ideas into mechanical form. Unlike Orville, who was shy in public and dislike speaking before an audience, Will was a gifted orator whose outgoing personality never failed to impress observers. The two men made a formidable team; sharing ideas, criticizing and yet strengthening each other, they succeeded where others had failed.

In 1912, Wilbur testified before the U. S. District Court in New York in one of the many Wright patent infringement cases. His testimony in that case, *Wright Company v. Herring Curtiss and Glenn H. Curtiss,* forms a portion of the narrative that follows. His eloquent description of the Wright brothers' achievements has never been superseded.

"My brother and I became seriously interested in the problem of human flight in 1889, a little more than twelve years ago. . . . We knew that men had by common consent adopted human flight as the standard of impossibility. When a man said, "it can't be done; a man might as well try to fly," he was understood as expressing the final limit of impossibility. Our own growing belief that man might nevertheless learn to fly was based on the idea that while thousands of creatures of the most dissimilar bodily structures, such as insects, fishes, reptiles, birds, and mammals, were flying every day at pleasure, it was reasonable to suppose than men also might fly. . . . We, accordingly, decided to write to the Smithsonian Institution and inquire

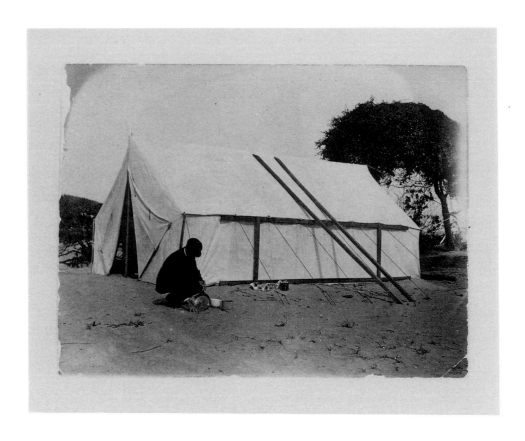

Plate 15. WILBUR SCOURING PANS WITH SAND, 1900

"But the sand! The sand is the greatest thing in Kitty Hawk, and soon will be the only thing. The site of our tent was formerly a fertile valley, cultivated by some ancient Kitty Hawker. . . .You can't get dirty. Not enough to raise the least bit of color could be collected under a fingernail. We have a method of cleaning dishes that has made the dishrag and the tea towel a thing of the past." Orville Wright to Katharine Wright, October 6, 1900.

Wright Photograph

for the best books relating to the subject. We received a reply recommending Langley's *Experiments in Aerodynamics*, Chanute's *Progress in Flying Machines* and *the Aeronautical Annuals* of 1895, 1896, and 1897, publications giving from year to year reports of efforts being made to solve the flying problem. The Smithsonian also sent us pamphlets, containing a reprint of Mouillard's *Empire of the Air*, Langley's *Story of Experiments in Mechanical Flight*, and a couple of papers by Lilienthal relating to *Experiments in Soaring*. When we came to examine these books, we were astonished to learn what an immense amount of time and money had been expended in futile attempts to solve the problem of human flight. Contrary to our previous impression, we found that men of the very highest standing in the profession of science and invention had attempted to solve the problem.

"At that time there was no flying art in the proper sense of the word, but only a flying problem. Thousands of men had thought about flying machines and a few had even built machines which they called flying machines, but these machines were guilty of almost everything except flying. Thousands of pages had been written on the so-called science of flying, but for the most part the ideas set forth, like the designs for machines, were mere speculations and probably ninety percent was false.

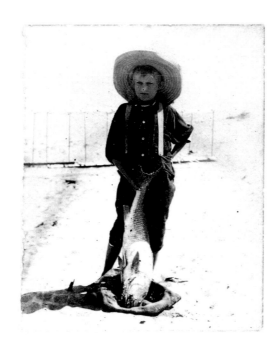

Plate 16. TOM TATE AND HIS "DRUM," 1900

"Tom is a small chap. . . .that can tell more big yarns than any kid of his size I ever saw. We took a picture of him as he came along the other day on his way home from the beach with a drum almost as large as he. The drum is a salt-water fish." Orville Wright to Katharine Wright, October 18, 1900.

Wright Photograph

"As to the state of experimental knowledge at the time we began our experiments, we reached the conclusion that the problem of constructing wings sufficiently strong to carry the weight of the machine itself, along with that of the motor and of the aviator, and also that of constructing sufficiently light motors were sufficiently worked out to present no serious difficulty; but that the problem of equilibrium had been the real stumbling block in all serious attempts to solve the problem of human flight, and that this problem of equilibrium in reality constituted the problem of flight itself. We, therefore, decided to give our special attention to inventing means of retaining equilibrium, and as this was a field where mere speculation was of no value at all, we made a careful study of the state of the experimental knowledge. . . .

"All experiments in the air had resulted in such immediate disaster that the first trial was not usually followed up. . . .The period of unexampled activity, which extended from 1889 to 1897, was followed by one of complete collapse and despair. . . .During the "boom" period fully a half million dollars had been expended under the direction of some of the ablest men in the world and two lives had been lost. When we studied the story of loss of life, financial disaster and final failure which had accompanied all attempts to solve this problem of human flight, we understood

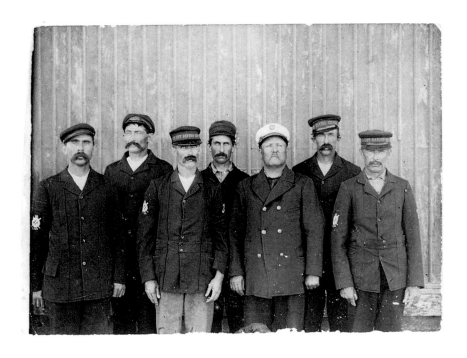

Plate 17. CREW OF THE KILL DEVIL HILL LIFESAVING STATION, 1900

In 1874 a chain of seven lifesaving stations was established on the Outer Banks of North Carolina.
There was one on the beach opposite Kitty Hawk village and another just east of Kill Devil Hills.
The Wrights grew to depend on crew members for assistance in moving and
launching the flying machines.

Wright Photograph

more clearly than before the immensity of the difficulty of the problem we had taken up. . . .

"We began to study the flight of birds to see whether they really used the methods of maintaining equilibrium which Chanute and Mouillard had represented the birds as using. . . .But in watching the flight of some pigeons one day, we noticed one of the birds tilted so that one wing was elevated above and the other depressed below normal position, and then tilted in the opposite direction. These lateral tiltings, first one way and then the other, were repeated four or five times very rapidly; so rapidly, in fact, as to indicate that some other force than gravity was at work. . In considering possible explanations of the method used by the bird in this instance, the thought came (Here was the silent birth of all that underlies human flight) that possibly it had adjusted the tips of its wings about a lateral transverse angle so as to present one tip at a positive angle and the other at a negative angle, thus, for the moment, turning itself into an animated windmill, and that when its body had revolved on a longitudinal axis as far as it wished, it reversed the process and started to turn the other way. Thus balance was controlled by utilizing dynamic reactions of the air instead of shifting weight. . . .

"We hit on the idea of providing a structure consisting of superposed surfaces rigidly trussed along their

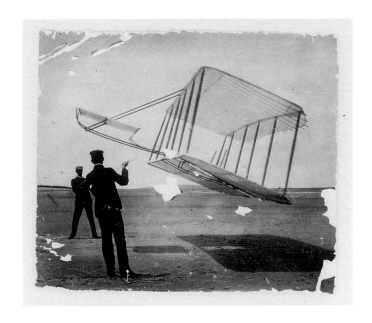

Plate 18. Glider Being Flown as a Kite, 1901

"We find from Mr. Huffaker that he and Chanute have greater hopes of our machine than we have ventured to hold ourselves. In fact they seem to have little doubt that we will solve the problem if we have not already really done so, so far as the machine itself is concerned. Mr. Huffaker remarked that he would not be surprised to see history made here in the next six weeks. Our own opinion is not so flattering. He is astonished at our mechanical facility, and as he has attributed his own failures to the lack of this, he thinks the problem solved when these difficulties are overcome, while we expect to find further difficulties of a theoretical nature which must be met by new mechanical designs."
Wilbur Wright to Milton Wright, July 26, 1901.

Wright Photograph

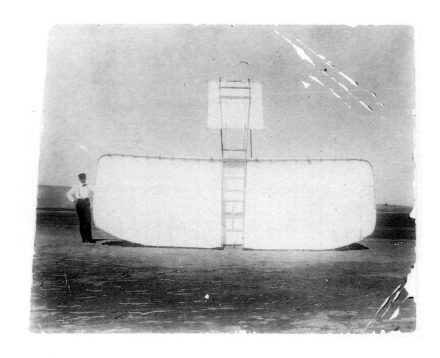

Plate 19. ORVILLE AND THE 1901 GLIDER

Span: 22 feet, Chord: 7 feet, Gap: 4 feet 8 inches, Wing Area: 290 square feet,
Horizontal Rudder Area: 18 square feet, Length: 14 feet,
Weight: 98 pounds; with sand ballast and trussing, 108 pounds

Wright Photograph

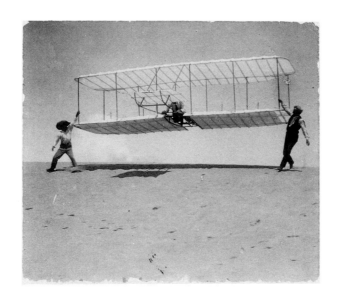

Plate 20. Dan Tate and Edward C. Huffaker Launch the 1901 Glider

"We expect to be careful to avoid real risks. We do not think there is any real danger of serious injury in the experiments we make. We will not venture on thin ice until we are certain that it will much more than bear us." Wilbur Wright to Milton Wright, July 26, 1901.

Wright Photograph

front and rear margins, but not trussed from front to rear. . . .Thus there would be no change in the general position of the upper surface to the front or rear of its normal position, but the entire structure would be given a warp like that shown in the patent in suit. We reasoned that by imparting such warp we could control lateral balance of the machine, either for the purpose of balancing or steering, as we had noticed that when the birds were tilted, they circled around the depressed wing. . . .This speculation was very interesting from a theoretical standpoint, but when we came to consider it from a standpoint of practical invention, we were convinced that without any supplementary horizontal surface the machine would be too erratic to be controlled by an aviator. . . .Before attempting to construct a glider on this general principle, we worked out the construction of the supporting planes and the mode of flexing a horizontal rudder shown in the patent suit. The horizontal rudder was placed at the front. There was no tail of any kind, either vertical or horizontal."

The young Wright brothers translated the theories Wilbur recalled in his testimony into an experimental device: a kite. But they soon discovered that their experiments would fail without a stronger, more reliable and sustained wind than in Dayton. Since they hoped to move from kites to manned machines, the Wrights also needed a soft sand landing area.

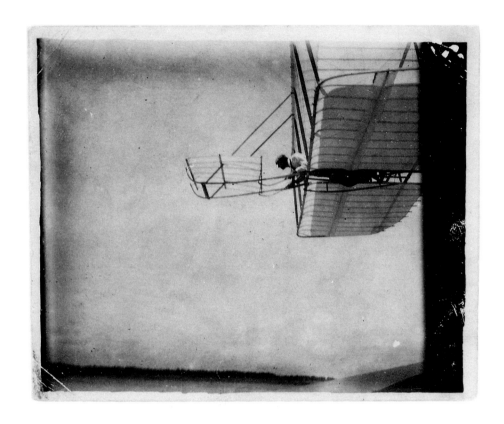

Plate 21. 1901 GLIDER IN FLIGHT, WILBUR AT THE CONTROLS

"Mr. O. Chanute. . . .now recognized as the leading authority of the world in aeronautics, was here to
visit us last week. He was very much astonished at our views and methods and results, and after
studying the matter overnight, said that he had reached the conclusion that we would
probably reach results before he did."
Wilbur Wright to Reuchlin Wright, July 3, 1901.

Wright Photograph

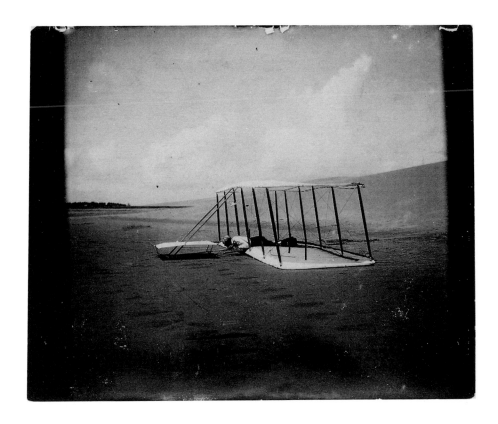

Plate 22. WILBUR AT THE END OF A GLIDE, 1901

"In my experiments I do not expect to rise many feet from the ground, and in case I am upset there is nothing but soft sand to strike on. I do not intend to take dangerous chances, both because I do not wish to get hurt and because a fall would stop my experimenting, which I would not like at all." Wilbur Wright to Milton Wright, September 23, 1900.

Wright Photograph

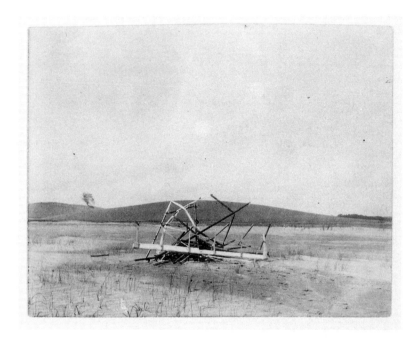

Plate 23. The "$1000 Beauty" — Wreck of the Chanute-Huffaker Glider

"I enclose a few prints. That of the Huffaker machine you will please not show too
promiscuously. I took it as a joke on Huffaker but afterwards it struck me that the joke was
rather on Mr. Chanute, as the whole loss was his. If you ever feel that you have not got much
to show for your work and money expended, get out this picture and you will feel
encouraged." Wilbur Wright to George A. Spratt, September 21, 1901.
Octave Chanute had employed Edward C. Huffaker to build and fly an experimental glider of
Chanute's design at Kitty Hawk. The machine, constructed of cardboard tubes, was
destroyed by rain and proved a complete failure.

Wright Photograph

Writing to the U. S. Weather Bureau for information, the brothers learned that the Outer Banks of North Carolina, near Cape Hatteras, offered the conditions they desired. They were soon planning an expedition to a small village that would one day be world famous because of their work, Kitty Hawk.

In his later court testimony, Wilbur described the early experiments on the Outer Banks.

"With machines of this description we made experiments in the years of 1900 and 1901 near Kitty Hawk, N. C. Experimentation by gliding had been so discredited by the deaths of Lilienthal and Pilcher that we intended to practice with this apparatus by attaching to it a short horizontal rope and letting it float in a strong wind a few feet from the ground while we practiced the manipulation of the horizontal front rudder and the warping of the wings to maintain the apparatus in balance. But we found that a stronger wind that the scientific calculations of other experimenters indicated was necessary to sustain this machine. It was, therefore, necessary to resort to gliding. . . .We found that the flexible front rudder was very efficient in controlling fore and aft balance. We also found that frequently we could make glides of fifteen to twenty seconds without being tilted laterally sufficiently to necessitate landing. If the tilting was bad, we immediately brought the machine down.

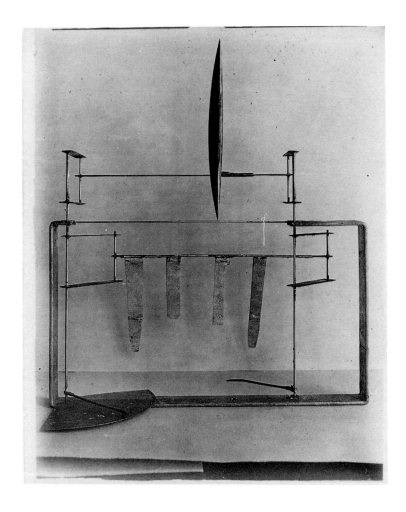

Plate 24. WIND TUNNEL LIFT BALANCE, 1901-02

"We have been experimenting somewhat with an apparatus for measuring the pressure of air on variously curved surfaces at different angles and have decided to purpose a table which we are certain will be much more accurate than that of Lilienthal." Wilbur Wright to Milton Wright, October 24, 1901. Otto Lilienthal was an influential German aviation pioneer.

Wright Photograph

"After we had acquired some skill in handling the horizontal front rudder, we loosened the warping wires and attempted to control the lateral balance also, but when we did this, we found ourselves completely nonplussed. The apparatus did not act at all as we had expected. At first we were not able to determine exactly what it did do, but it was clear enough that it was not what we wanted in all respects. We repeated the trials for the purpose of determining, if possible, exactly what happened, but found this no easy task.

"To the person who has never attempted to control an uncontrollable flying machine in the air, this may seem somewhat strange, but the operator on the machine is so busy manipulating his rudder and looking for a soft place to alight, that his ideas of what actually happens are very hazy. It is much nicer to sit before a pleasant fire and speculate, than to work out, at the risk of life and limb, the construction necessary to reduce speculation to practical invention.

"After repeated experiments we began to perceive that in landing the machine was skidding somewhat toward the wing having the smaller angle and was facing somewhat toward the wing having the greater angle, and the wing having the greater angle seemed to touch first. As our season was now at a close, we were compelled to leave the problem in this condition. These experiments constituted

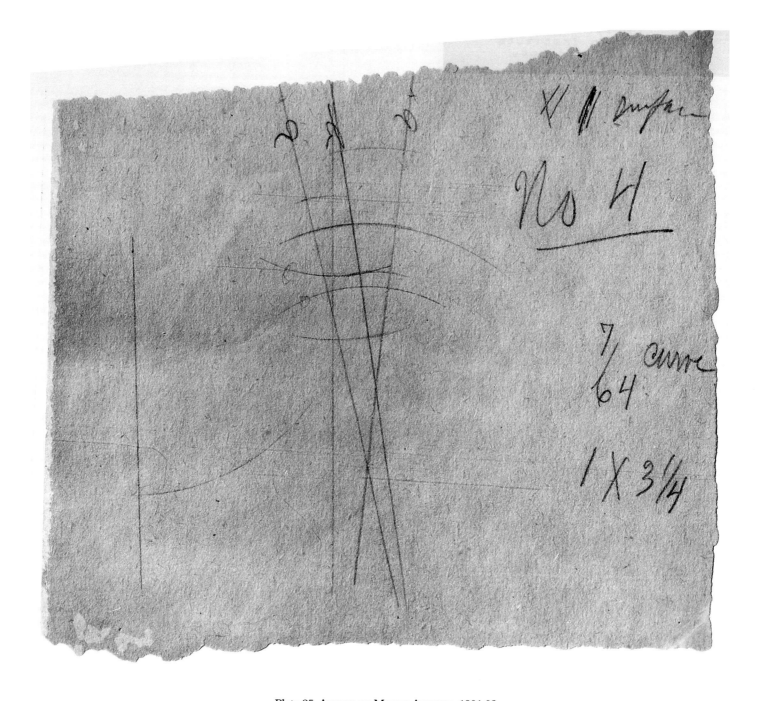

Plate 25. ANGLES OF MODEL AIRFOILS, 1901-02

This is an example of the earliest existing records of the wind tunnel experiments of 1901. The angles assumed by model airfoils, mounted on a vane-type balance in a wind tunnel of their own design, were traced on wallpaper fragments by the thrifty Wrights.

Courtesy of The Franklin Institute, Philadelphia, Pennsylvania

the first instance in the history of the world that wings adjustable to different angles of incidence on the right and left sides had been used in attempting to control the balances of an aeroplane. . . .When we left Kitty Hawk at the end of 1901, we doubted that we would ever resume our experiments. . . .At this time I made the prediction that men would sometime fly, but that it would not be within our lifetime. . . as the problem of stability. . . .was yet seemingly untouched, so far as a practical solution was concerned."

At first discouraged, the Wrights soon regained their enthusiasm. Octave Chanute, the grand old man of aeronautics, began the process of drawing the brothers back to aviation. In August 1901, he invited Wilbur to Chicago to address the Western Society of Engineers. This invitation to appear for the first time before a scientific professional audience forced Wilbur to confront the results of the 1900 and 1901 experiments. Increasingly, he had come to doubt the accepted tables of lift, drag, and pressure derived from the experiments of Lilienthal and others. This address also forced him to confront those discrepancies squarely.

The Chicago expedition was a personal as well as an intellectual trial for Wilbur. At first reluctant to go, he was "nagged" into the journey by sister Katharine. She saw, correctly, that the chance to meet with "scientific men" would be a tonic for his depressed spirits. Will's wardrobe was not up to the event, in the family's opinion, and he was persuaded to borrow clothes from Orville, always the better dresser. In his brother's topcoat, shirt, collar, tie, and cufflinks, Wilbur made a splendid appearance. When Katharine asked him whether his speech was to be "witty or scien-

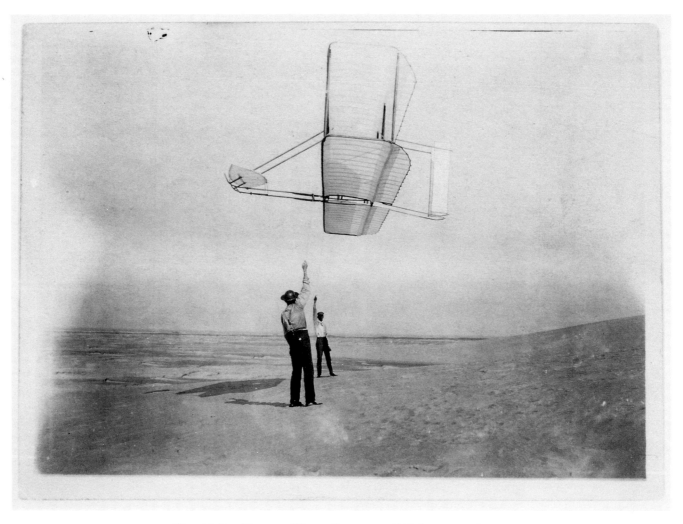

Plate 26. Dan Tate and Wilbur Flying the 1902 Glider as a Kite

"We had it out making some tests of its efficiency today and are very much pleased with the results of our measurements. . . .In a test for "soaring" as a kite the cords stood vertical or a little to the front on a hill having a slope of only 7 1/2˚. This is an immense improvement over last year's machine."
Wilbur Wright to George A. Spratt, September 16, 1902.

Wright Photograph

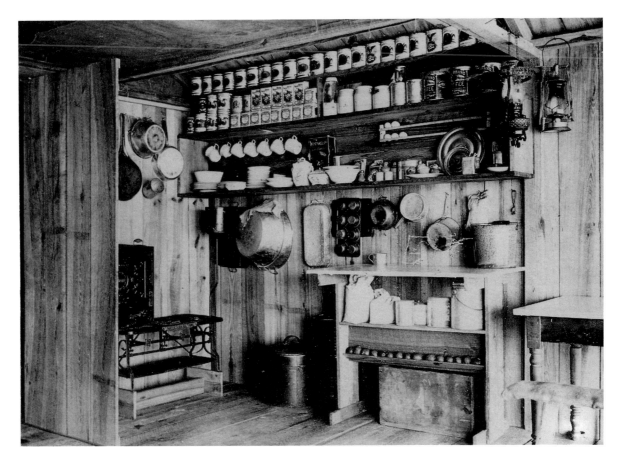

Plate 27. KITCHEN OF THE 1902 CAMP

"About the only exciting experiences we have had so far were in pursuit of a little mouse which has a
habit of coming out every night and prowling around in the kitchen, over the stove, rattling through
the tin oven, overturning a tin can or two in trying to peep into them for something to eat"
Orville Wright to Katharine Wright, September 7, 1902.

Wright Photograph

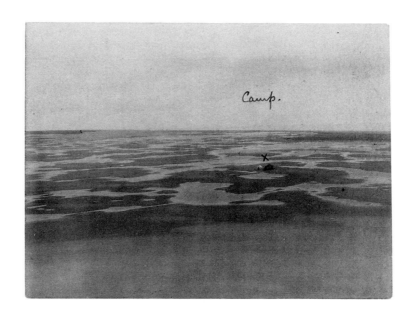

Plate 28. DISTANT VIEW OF THE 1902 CAMP

"The wind has blown the foundation out from the ends of our building so that the ends stand in small ponds after a rain thus giving us a bath room at small cost! The floor has a pleasing curved effect which is very swell. . . .So far in addition to cookery we have exercised ourselves in the trades of carpentry, furniture making, upholstering, well driving and will add house moving next week." Wilbur Wright to Katharine Wright, August 31, 1902.

Wright Photograph

tific," Wilbur replied that he "thought it would be pathetic before he got through with it." The talk became one of the most important addresses in the history of aeronautics. Published in the *Journal of the Western Society of Engineers,* Wilbur's speech brought the Wrights' name out of obscurity. Henceforth, their work would be followed closely by the aeronautical fraternity and, particularly in France, would have an increasing influence on other experimenters.

Back in Dayton, Wilbur and Orville began their most serious and fundamental experiments. Still convinced that the tables of lift and drag were not reliable, the brothers devised a series of experiments designed to test these long-accepted axioms. During the months of November and December 1901, they tested a series of model air foils in a wind tunnel of their own design, using balances built from scratch. The resulting tables were by far the most accurate to that time and remain the basis for subsequent serious aeronautical research. Wilbur in his 1912 deposition described how he and his brother puzzled out the problems of control during that fruitful winter of 1901-1902.

"After our return home, we could not keep our minds off of the puzzling things we had observed, nor keep from studying possible solutions of our difficulties, and before long we were as deeply interested as before. In studying our troubles relating to lateral balance, we reasoned that possibly the trouble might be due to the fact that the wing to which an increased angle of incidence had been imparted would receive not only an increased lift, but

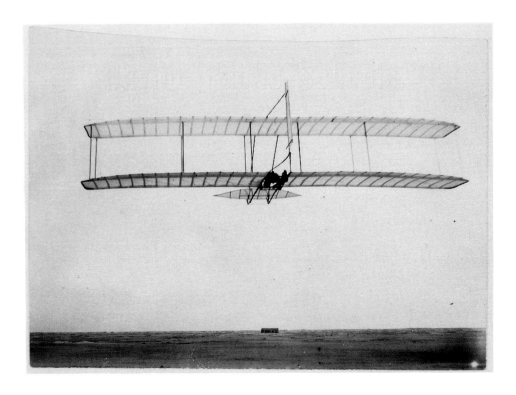

Plate 29. 1902 GLIDER IN FLIGHT, WITH THE CAMP IN THE FAR BACKGROUND

This photograph gives a sense of both the isolation of the Kitty Hawk region and the level of skill the Wrights had achieved as pilots by 1902. With the perfection of their control system, Wilbur and Orville were ready to add a motor to the glider and demonstrate a truly practical airplane.

Wright Photograph

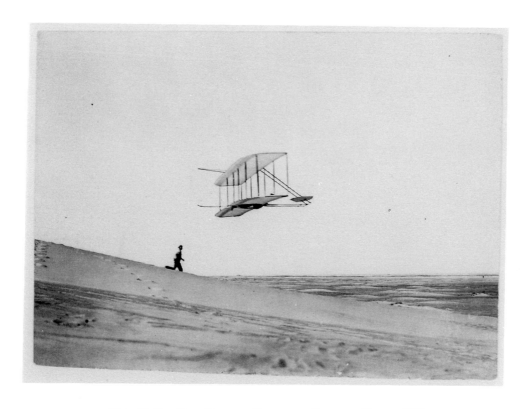

Plate 30. DAN TATE RUNNING BESIDE THE GLIDER IN FLIGHT, 1902

"We have gained considerable proficiency in the handling of the machine now, so that we are able to
take it out in any kind of weather. . .we now hold all the records!
The largest machine we handled in any kind of weather, made the longest distance glide (American),
the longest time in the air, the smallest angle of descent, and the highest wind!!!"
Orville Wright to Katharine Wright, October 23, 1902.

Wright Photograph

REGULATOR DIARY

SIMMONS

J.H.ZEILIN

LIVER

&C Co

MEDICINE

REGULATOR

J.H. ZEILIN & CO.

Sole Proprietors

PHILADELPHIA.

MEMORANDA
Simmons Liver Regulator—Purely Vegetable.

WW { 548 ft 8° 50'
 22 seconds
 6½ at top 4 at bottom

OW { 505 ft – 8° 30'
 24¼ seconds
 6½ top 4 meters bottom

OW { 406½ feet
 18 seconds
 6½ top 4 at bottom

OW { 335 ft 7° 0'
 16½ seconds
 6¼ meters wind at middle

Oct. 21 A.M.
wind 16 miles to 1 P. and
150 ft 13½ sec flew with
anemometer 134 miles
angle 7°

6 22

Plate 31.
"REGULATOR DIARY,"
1902

Each year the Wrights
recorded aeronautical
data in a series of
small vest-pocket
notebooks. In 1902
they used a
burgundy-covered
pharmaceutical
notebook. Entries
on this page were
made by Orville.

*Courtesy of the
Library of
Congress,
Washington, D.C.*

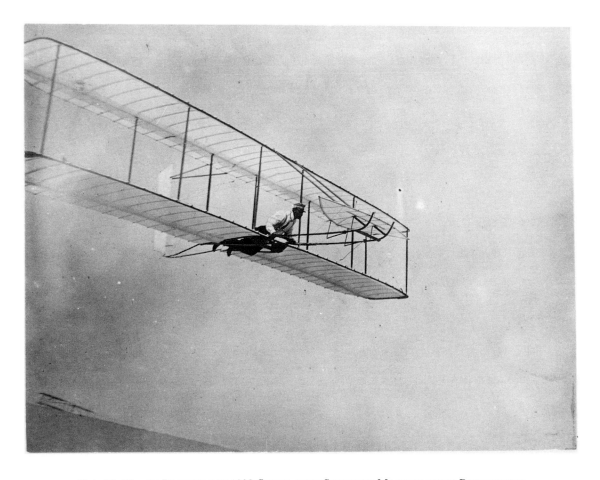

Plate 32. WILBUR PILOTING THE 1902 GLIDER, WITH CHANUTE'S MACHINE IN THE BACKGROUND

"We have. . . .greatly increased the amount of practice, which we consider to be the only thing now lacking to attain soaring flight. The action of the machine is almost perfect, or rather it controls both fore-and-aft and transversely just as we wish it to; and the capacity for control if properly utilized will meet any emergency, we think" Wilbur Wright to Octave Chanute, September 23, 1902.

Wright Photograph

also an increased backward pressure or resistance and that this might so decrease the speed of the wing, as compared to the opposite wing, that its lift would be reduced sufficiently from this cause to wipe out the increase in lift, due to its greater incidence. . . .We reasoned that if the speeds of the right and left wings could be controlled, the advantage of the increased angle of incidence of one wing and decreased angle of the other could be utilized as we had originally intended. . . .We decided to use the surface at the rear. . . .and, for the sake of simplicity, we decided to use a fixed vertical vane, as we reasoned that if the machine attempted to turn on a vertical axis, the vane at the rear would be exposed more and more to the wind and would stop further turning of the machine. . . .

"In the fall of 1902, we returned to Kitty Hawk with an apparatus fitted with a fixed vertical vane at the rear. When tried we found that under favorable conditions the apparatus performed as we had expected, so that we could control lateral balance or steer to the right or left by the manipulation of the wing tips. This was the first time in the history of the world that lateral balance had been achieved by adjusting wing tips to respectively different angles of incidence on the right and left sides. It was also the first time that a vertical vane had been used in combination with the

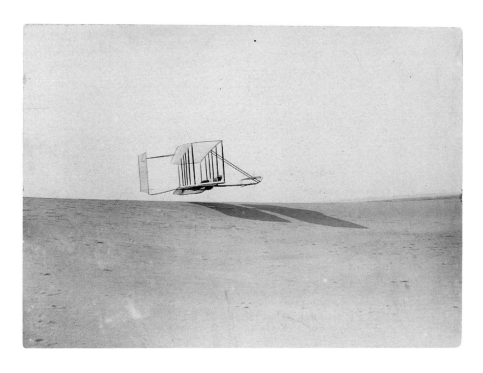

Plate 33. ORVILLE MAKING A TURN IN FLIGHT, 1902

"In this line - that of flying - I am now making great claims - holding the record in angle of flight. I glided 160 feet with a drop of only one foot for every 10 forward, or from 25 to 50 percent better than has been done by any machine before. I not only succeeded in smashing the record; I smashed the machine too, and it, as a result, has been in the repair shop. . . .The machine is a great improvement over last year's machine, and comes fully up to our expectations. The control will be almost perfect, we think, when we once learn to properly operate the rudders. They have much more power than those on last year's machine, and besides, turn the machine in the desired direction - something our former machines were deficient in" Orville Wright to Katharine Wright, September 29, 1902.

Wright Photograph

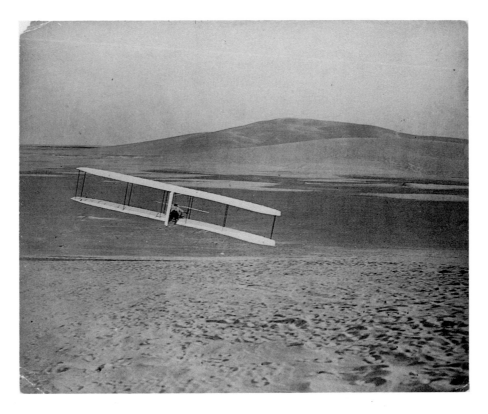

Plate 34. Wilbur Demonstrating the Turning Ability of the Moveable Single Rudder, 1902

"We are in splendid health and having a fine time. . .Our new machine is a very great improvement over anything we had built before and over anything anyone has built. We have far beaten all records for flatness of glides. . .The new machine is also much more controllable than any heretofore built so the danger is correspondingly reduced. . .Everything is so much more satisfactory that we now believe that the flying problem is really nearing its solution." Wilbur Wright to Milton Wright, October 2, 1902.

Wright Photograph

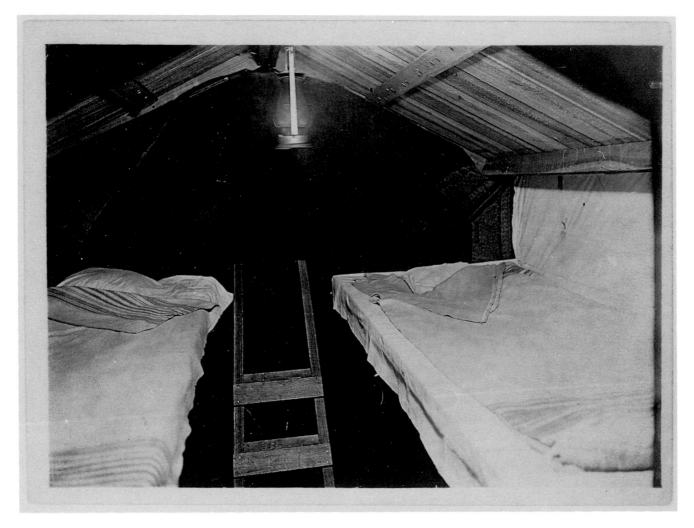

Plate 35. THE "PATENT BEDS" IN THE SLEEPING LOFT OF THE 1902-03 CAMP

"We have made a number of improvements in our building so it is much tighter and more convenient
than it was last year. We now sleep in the upper story in some new style beds which are a great
improvement over the little cots we formerly used."
Wilbur Wright to Milton Wright, September 12, 1902.

Wright Photograph

wing tips, adjustable to respectively different angles of incidence, in balancing and steering an aeroplane.

"But as we proceeded with our experiments, we found that the expected results were not always attained. Sometimes the machine would turn up sideways and come sliding to the ground in spite of all the warp that could be imparted to the wing tips. This seemed strange. The apparatus would sometimes perform perfectly and at other times, without any apparent reason, would not perform at all. Every now and then it would come tumbling to the ground and make such a rough landing that we often considered ourselves lucky to escape unhurt. By taking the chance over and over we finally began to notice the conditions under which the difficulty was liable to occur. . . .If the tilt happened to be a little worse than usual, or if the operator was a little slow in getting the balance corrected, the machine slid sideways so fast that the sideways movement of the machine caused the vertical vane to strike the wind on the side toward the low wing instead of on the side toward the high wing, as it should have done. In this state of affairs, the vertical vane, instead of counteracting the turning of the machine. . . .on the contrary assisted in its turning movement and the result was worse than when the vertical vane was absent.

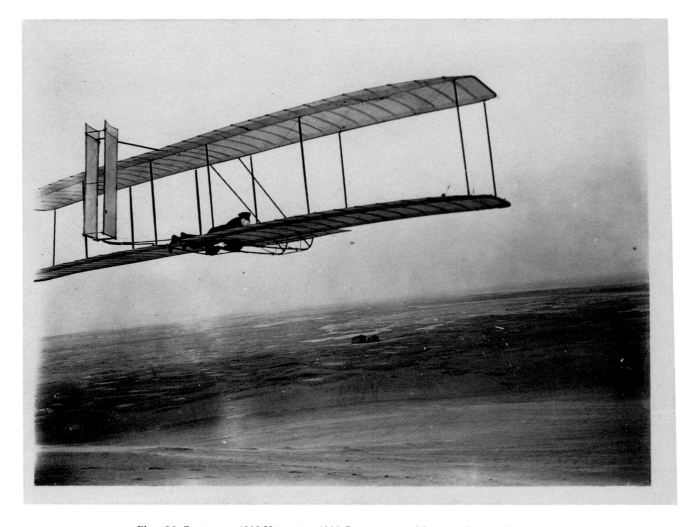

Plate 36. GLIDING IN 1903 USING THE 1902 GLIDER WITH A MOVABLE DOUBLE RUDDER

To gain the greatest amount of practice in the air before trying out the Flyer, the brothers made many glides with the old 1902 glider. They thus familiarized themselves with the control system before committing to a motorized test.

Wright Photograph

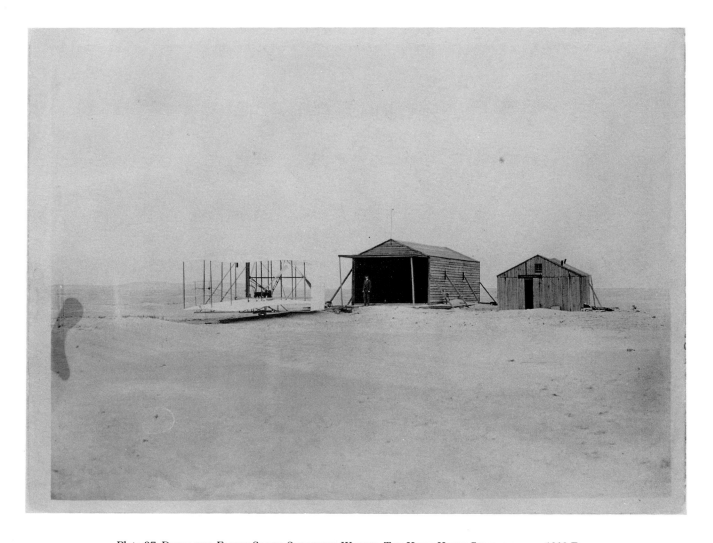

Plate 37. DESOLATE, EMPTY SANDS SURROUND WILBUR, THE KITTY HAWK CAMP, AND THE 1903 FLYER

"We completed attachments for working vert. tail, and got machine about ready for trial. In taking it out of the building one of the hubs in our truck broke. . . .While machine was outside of building we found cent. of gravity with man to be very close to 24" from front edge and about halfway between man and engine" Orville Wright, Diary D, November 24, 1903.

Wright Photograph

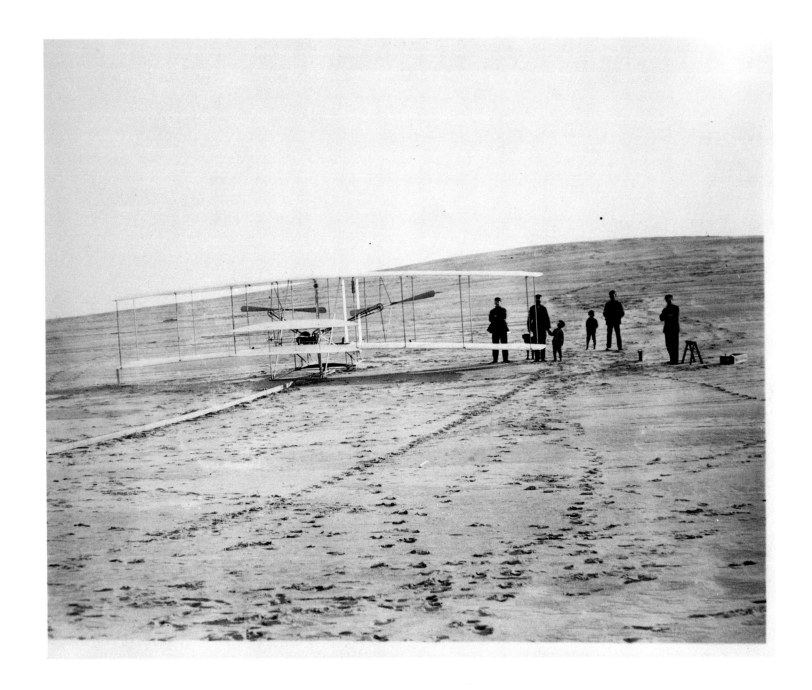

Plate 38. FLYER ON TRACK BEFORE LAUNCH, DECEMBER 14, 1903

"After testing engine, with help of men. . . .we took machine 150 ft. uphill and laid track on 8° 50' slope. A couple small boys, who had come with the men from the station, made a hurried departure over the hill for home on hearing the engine start" Orville Wright, Diary D, December 14, 1903.

Wright Photograph

"We felt that if this was the true explanation, it would be necessary to make the vertical vane moveable in order that the pressure on the side toward the low wing might be relieved and the pressure brought to bear on the side toward the high wing. . . .For the sake of simplicity, we, therefore, decided to attach the wires controlling the vertical tail to the wires warping the wings. . . .With this apparatus we made nearly seven hundred glides in the two or three weeks following. We flew it in calms and we flew it in winds as high as thirty-five miles an hour. We steered it to the right or left and performed all the evolutions necessary for flight. This was the first time in the history of the world that a moveable vertical tail had been used in controlling the direction or the balance of a flying machine. It was also the first time that a moveable vertical tail had been used, in combination with wings adjustable to different angles of incidence, in controlling the balance and direction of an aeroplane. We were the first to functionally employ a moveable vertical tail in a flying aeroplane. We were the first to employ wings adjustable to respectively different angles of incidence in a flying aeroplane. We were the first to use the two in combination in a flying machine."

After the outstanding success of the 1902 glider, the Wrights felt confident that the problems of stability and control were solved. The next step was to put a motor

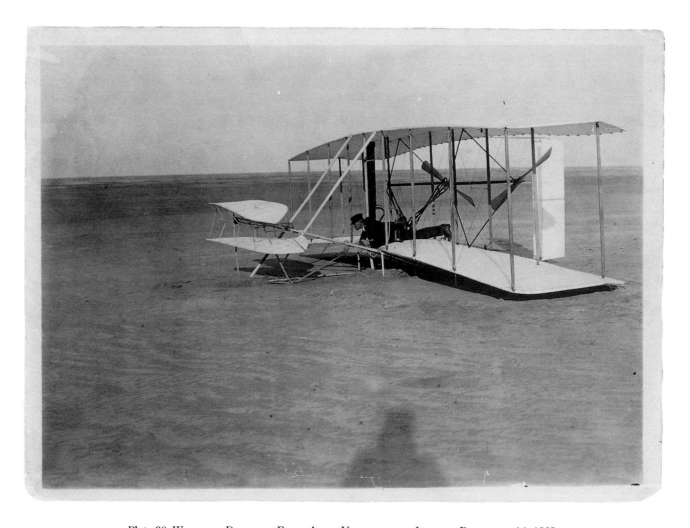

Plate 39. Wilbur in Damaged Flyer After Unsuccessful Launch, December 14, 1903

"However, the real trouble was an error in judgement. . . .before I could correct the error, the machine began to come down, though turned up at a big angle. . . .A few sticks in the front rudder were broken, which will take a day or two to repair probably. It was a nice easy landing for the operator."
Wilbur Wright to Katharine Wright, December 14, 1903.

Wright Photograph

and propellers onto the glider, or onto a larger, sturdier version of the glider, and produce a true aeroplane. In this process, which was greatly overshadowed by the publicity given their invention, the Wrights developed the first true theory of the modern aircraft propeller. They also designed and built their own power plant, a remarkably efficient aluminum-block motor which was almost entirely the work of their gifted mechanic, Charles Taylor.

Ready at last to test the "Flyer," the boys returned to the familiar campsite at Kitty Hawk. By now these annual pilgrimages had become almost routine. Offering a taste of wilderness adventure as well as scientific experimentation, Kitty Hawk was a far cry from the Victorian proprieties of Dayton, Ohio. Still, by 1903, the campsite offered many of the comforts of home. Tents had been replaced by sturdy wooden buildings equipped with stoves, furniture, and "patent beds" slung among the rafters.

Nevertheless, mosquitoes plagued the intrepid aviators, sandstorms blew the foundations out from under the buildings and the nights grew so cold that the Wrights huddled under five or six blankets. They depended for help on the hard-bitten crews of the local lifesaving stations. Wilbur and Orville relished these visits to the isolated barrier islands, and though they continued to dress in the proper outfits of Edwardian gentlemen, the brothers returned from these expeditions tanned and fit from the healthy outdoor life. In 1903, ready at last to test their machine, they made what would be their last trip to Kitty Hawk in five years. Wilbur's deposition described the culmination of their work.

"We now felt that the problem of human flight
was solved and accordingly proceeded to make application

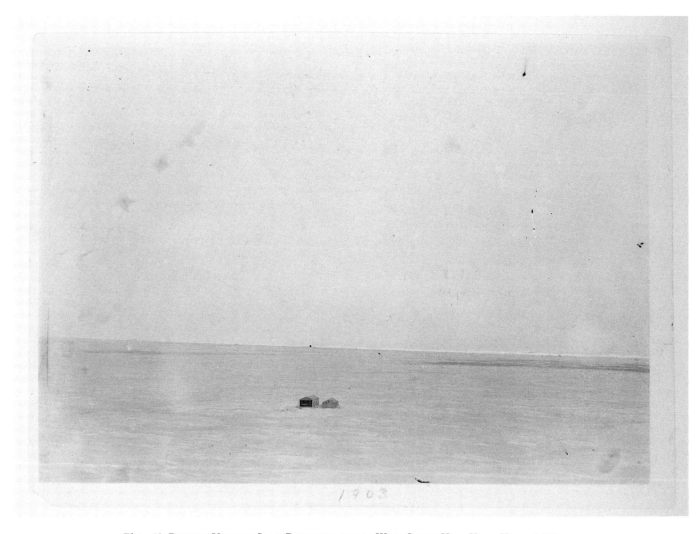

1903

Plate 40. DISTANT VIEW OF CAMP BUILDINGS FROM A WIND SWEPT HILL, KITTY HAWK, 1903

Wright Photograph

for patent and began to draw up designs for a practical motor-driven aeroplane. We constructed the parts in our little shop in Dayton, Ohio, and assembled it on the sand dunes at Kitty Hawk in the latter part of the year 1903. On the 17th of December we made four successful flights, of which the last had a duration of 59 seconds. The machine, with an operator aboard, in this flight flew a distance of more than 850 feet. . . .In a statement which we gave to the press, which was published in most of the newspapers of the United States about the 7th of January, 1904, we said:

"Only those who are acquainted with practical aeronautics can appreciate the difficulties of attempting the first trial of a flying machine in a 25-mile gale. As winter was already well set in we should have postponed our trials to a more favorable season but for the fact that we were determined before returning home to know whether the machine possessed sufficient power to fly, sufficient strength to withstand the shock of landings and sufficient capacity of control to make flight safe in boisterous winds, as well as in calm air. When these points had been definitely established, we at once packed our goods and returned home, knowing that the age of the flying machine had come at last."

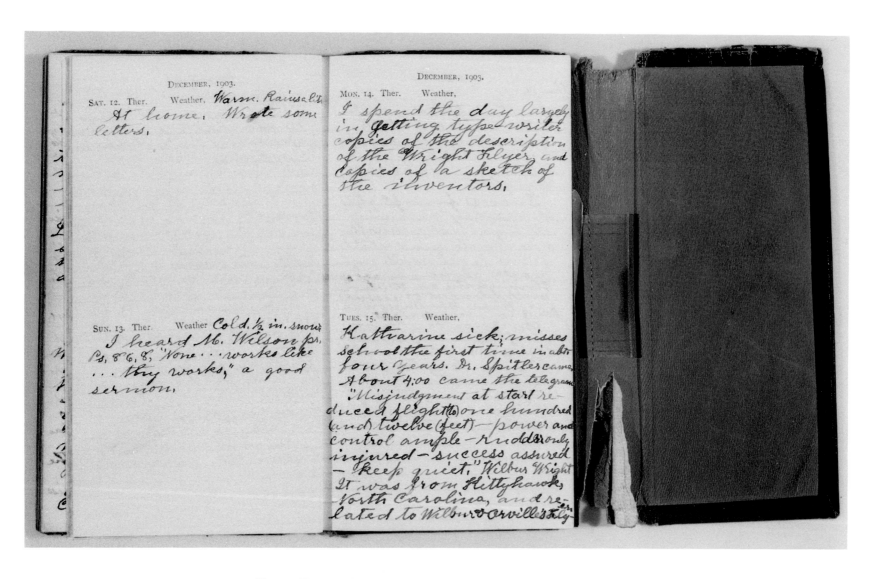

Plate 41. ENTRY IN BISHOP MILTON WRIGHT'S DIARY, DECEMBER 15, 1903

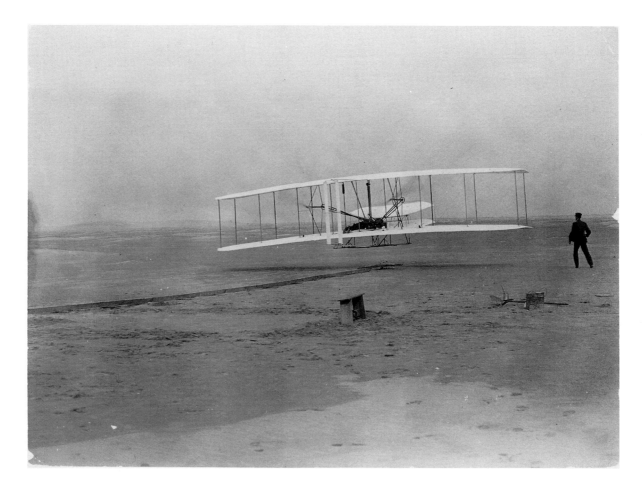

Plate 42. THE FIRST FLIGHT, DECEMBER 17, 1903

Before the 120-foot, twelve-second flight, Orville positioned the camera, instructing Kitty Hawk resident J. T. Daniels when to activate the shutter. This was the world's first free, controlled, and sustained flight in a heavier-than-air power-driven airplane.

Wright Photograph

by noon and got the machine out on the tracks in front of the building ready for a trial from the level. The wind was gradually dying and by the time we were ready was blowing only about 4 to 5 meters per sec. After waiting several hours to see whether it would breeze up again we took the machine in.

Thursday, Dec. 17th

When we got up a wind of between 20 and 25 miles was blowing from the north. We got the machine out early and put out the signal for the men at the station. Before we were quite ready, John T. Daniels, W. S. Dough, A. D. Etheridge, W. C. Brinkley of Manteo, and Johnny Moore, of Nags Head arrived. After

running the engine and propellers a few minutes to get them in working order, I got on the machine at 10:35 for the first trial. The wind according to our anemometers at this time was blowing a little over 20 miles (corrected) 27 miles according to the Government anemometer at Kitty Hawk. On slipping the rope the machine started off increasing in speed to probably 7 or 8 miles. The machine lifted from the track just as it was entering on the fourth rail. Mr. Daniels took a picture just as it left the tracks. I found the control of the front rudder quite difficult on account of its being balanced too near the center and thus had a tendency to turn itself when started so that the rudder was turned too far on one side and then too

Plate 43. ENTRY IN ORVILLE WRIGHT'S DIARY, DECEMBER 17, 1903

Courtesy of the Library of Congress, Washington, D. C.

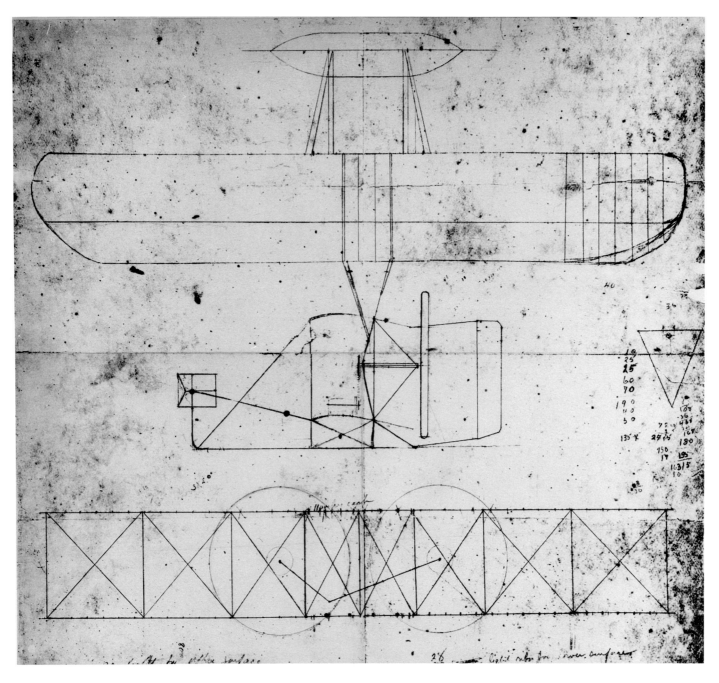

Plate 44. PRELIMINARY THREE-VIEW SKETCH OF THE 1903 FLYER, DRAWN IN PENCIL ON BROWN WRAPPING PAPER
Notations are in Wilbur Wright's handwriting. The original sketch is mounted on cardboard.

Courtesy of The Franklin Institute, Philadelphia, Pennsylvania

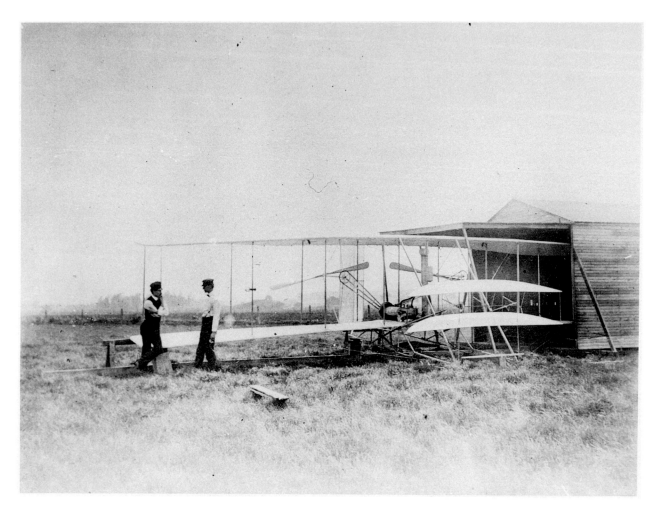

Plate 45. ORVILLE AND WILBUR POSING WITH THE "1904 FLYER," HUFFMAN PRAIRIE (SIMMS STATION), 1904

"The machine is held until ready to start by a sort of trap to be sprung when all is ready; then with a tremendous flapping and snapping of the four-cylinder engine, the huge machine springs aloft. When it first turned that circle, and came near the starting point, I was right in front of it; and I said then, and I believe still, it was one of the grandest sights, if not the grandest sight of my life. Imagine a locomotive that has left its track and is climbing up in the air right toward you - a locomotive without any wheels. . . .but with white wings instead. . . .coming right toward you with the tremendous flap of its propellers, and you will have something like what I saw. The younger brother bade me move to one side for fear that it might come down suddenly; but I tell you, friends, the sensation that one feels in such a crisis is something hard to describe"
Amos I. Root, Medina, Ohio, *Gleanings in Bee Culture,* January 1, 1905

Wright Photograph

66

EUROPE AND AMERICA

———◆———

THE FIRST FLIGHTS AT KITTY HAWK on December 17, 1903, were an epoch-making achievement, but the Wrights knew they had a long road to travel before they developed a truly practical airplane. The Kitty Hawk Flyer was underpowered, clumsy, and hard to control. The brothers would need months of practice to perfect their flying skills. While they were discussing the last and longest flight of the day and contemplating some small repairs necessitated by a hard landing, a strong gust of wind suddenly upended the plane and rolled it over, causing irreparable damage and bringing the 1903 flying season to an end.

The boys were glad to return to Dayton for Christmas. The Wright family was close-knit and family holidays were important to Bishop Wright, Katharine, and the brothers. The Kitty Hawk adventures, told and retold over the holiday dinner table, formed a recurring theme for family tales for years to come.

Knowing that they had solved in theory, if not yet mastered in practice, the problems of control and equilibrium in a flying machine, the Wrights had no need to return to North Carolina. The strong winds and soft sand at the Kill Devil Hills would be replaced by fields closer to home. They needed a spot accessible to their house and yet remote enough to discourage curiosity-seekers. They located a 100-acre pasture about fifteen miles east of Dayton owned by Torrence Huffman, a West Side banker who asked only that the aviators drive away the horses and cows before takeoff.

The field is referred to in the Wrights' records as "Huffman Prairie" or "Simms Station," a name derived from the station stop on the Dayton, Springfield & Urbana electric traction line. It was Orville and Wilbur's custom to ride the traction cars from their West Side home to the flying field each day, returning when it grew

Plate 46. ENTRY FROM WILBUR'S 1904-05 DIARY

This entry records the airplane's first successful complete circle.

Courtesy of the Library of Congress, Washington, D. C.

too dark to fly. There is something almost quaint about the image of these two pioneering inventors sedately riding the trolley out and back to Simms Station, perfecting the airplane within sight of and yet without much interest on the part of the commuters, shoppers, and traveling salesmen.

Much work remained to be done. As Wilbur stated in his deposition to the New York court, the airplane still had problems.

"While our patent application was pursuing its slow course through the Patent Office, we built a second machine and flew it in a field near the city of Dayton, Ohio, in the summer and autumn of 1904. When we had familiarized ourselves with the operation of the machine in more or less straight flights, we decided to try a complete circle. At first we did not know just how much movement to give in order to make a circle of a given size. On the first three trials we found that we had started a circle on too large a radius to keep within the boundaries of the small field in which we were operating. Accordingly a landing was made each time, without accident, merely to avoid passing beyond the boundaries of the field. On the fourth trial, made on the 20th of September, a complete circle was made, and the machine was brought safely to rest after having passed the starting point. Thereafter we repeatedly made circles, and on the 29th of November made four circles of the field in a flight lasting a few seconds over five minutes. . . .

Plate 47.
SECOND LONGEST FLIGHT
OF THE YEAR, 20.75 MILES,
HUFFMAN PRAIRIE,
OCTOBER 4, 1905

"I have your letter. . . .and I am enthused and delighted by what you tell me of your recent advance in performance. I congratulate you and your brother most heartily upon a success as well deserved as it is epoch-making. . . .It is a perfect marvel to me that you have kept your performances out of the newspapers so long. With so curious a public as our own. . . .I felt convinced that some enterprising reporter would discover you sometime and make you famous" Octave Chanute to Wilbur Wright, October 22, 1905

Wright Photograph

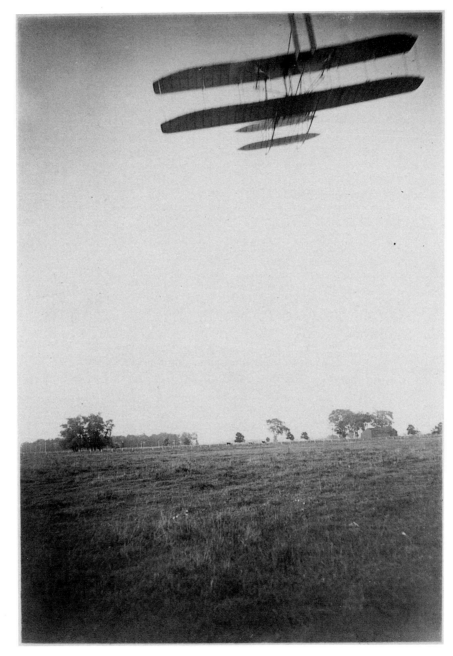

"With this machine we made approximately a hundred flights in the year 1904. Usually the machine responded promptly when we applied the control for restoring lateral balance, but on a few occasions the machine did not respond promptly and the machine came to the ground in a somewhat tilted position. The cause of the difficulty proved to be very obscure and the season of 1904 closed without any solution to the puzzle. In 1905 we built another machine and resumed our experiments in the same field near Dayton, Ohio. Our particular object was to clear up the mystery which we had encountered on a few occasions during the preceding year. During all the flights we had made up to this time we had kept close to the ground, usually within ten feet of the ground, in order that in case we met any new and mysterious phenomenon, we could make a safe landing.

"With only one life to spend we did not consider it advisable to attempt to explore mysteries at such great height from the ground that a fall would put an end to our investigations and leave the mystery unsolved. The machine had reached the ground, in the peculiar cases I have mentioned, too soon for us to determine whether the trouble was due to slowness of the correction or due to a change of conditions, which would have increased in intensity, if it had continued, until the machine would have been entirely

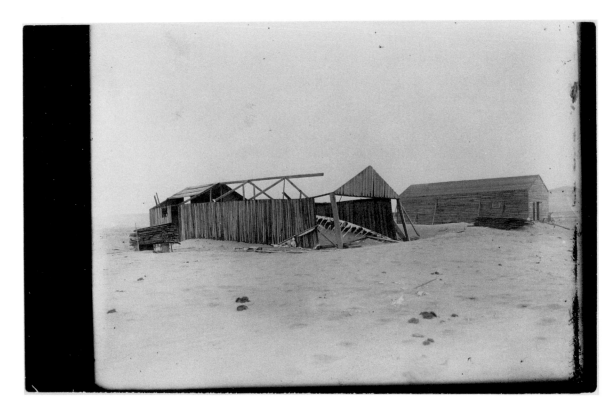

Plate 48. RUINS OF THE 1903 CAMP AND REMAINS OF THE 1902 GLIDER, KITTY HAWK, 1908

When the Wrights returned to Kill Devil Hills in 1908, they found the camp buildings partially demolished and the 1902 glider badly wrecked and almost covered with sand. Since they had not flown for three years and needed to refresh their skills before demonstrating the Flyer publicly in France and the U. S., the brothers practiced flying during April and May 1908 at their old flying grounds near Kitty Hawk.

Wright Photograph

overturned and quite beyond the control of the operator. Consequently it was necessary or at least advisable to discover the exact cause of the phenomenon before attempting any high flights.

"For a long time we were unable to determine the peculiar conditions under which this trouble was to be expected. But as time passed we began to note that it usually occurred when we were turning a rather short circle. We, therefore, made short circles sometimes for the purpose of investigating and noting the exact conduct of the machine from the time the trouble began until the landing was made. . . .The remedy was found to consist in the more skillful operation of the machine and not in a different construction. The trouble was really due to the fact that in circling, the machine has to carry the load resulting from centrifugal force, in addition to its own weight. . . .The machine in question had but slight surplus of power above what was required for straight flight, and as the additional load, caused by circling, increased rapidly as the circle became smaller, a limit was finally reached beyond which the machine was no longer able to maintain sufficient speed to sustain itself in the air. . . .

"In other words, the machine was in what has come to be known as a "stalled" condition. The phenomenon is common to all aeroplanes in the world and is the cause of

WESTERN UNION

Cable Message

WESTERN UNION

THE WESTERN UNION TELEGRAPH COMPANY.

─── INCORPORATED ───

ROBERT C. CLOWRY, President and General Manager.

THE LARGEST TELEGRAPH AND CABLE SYSTEM IN EXISTENCE. CABLE SERVICE TO ALL THE WORLD.

24,000 OFFICES AND 25,000 ADDITIONAL TELEGRAPH AND TELEPHONE CONNECTIONS IN NORTH AMERICA.

DIRECT AMERICAN CABLES NEW YORK TO GREAT BRITAIN.
CONNECTS also with ANGLO-AMERICAN and DIRECT U. S. ATLANTIC CABLES.
DIRECT COMMUNICATION WITH GERMANY AND FRANCE, CUBA, WEST INDIES, MEXICO and CENTRAL and SOUTH AMERICA.
WITH PACIFIC CABLES TO ALASKA, HONOLULU, AUSTRALIA, GUAM, THE PHILIPPINES, JAPAN, ETC.

Branch Offices in Principal Cities of Great Britain and the European Continent. All Foreign Telegraph Stations accept Messages to be sent

"Via WESTERN UNION."

NUMBER	SENT BY	REC'D BY	No. OF WORDS	FROM
90	DO	Q	6	Paris July 3/07

RECEIVED at _____ 190

Wrights,

 Dayton,(Ohio)

Siacepilin chinno emmant chapucagen .

759AM OK Q & DO

Plate 49. WESTERN UNION CABLE MESSAGE, SENT BY WILBUR TO ORVILLE FROM PARIS, JULY 3, 1907

"What is necessary to alter in offer French War Department? Negotiations are pending again." To preserve secrecy and protect their patent and business interests, they often exchanged their messages in code.

Courtesy of the Library of Congress, Washington, D. C.

frequent disaster to unskilled aviators. Our own machine is still subject to the same trouble. Within the last year [1911] four or five Wright machines have been wrecked by novices stalling the machines in attempting to climb too fast while circling, and have come tumbling to the ground, just as we did in 1905. . . .The remedy for this difficulty lies in more skillful operation of the aeroplanes. When we had discovered the real nature of the trouble, and knew that it could always be remedied by tilting the machine forward a little, so that its flying speed would be restored, we felt that we were ready to place flying machines on the market."

The Wrights have often been accused of deliberately avoiding publicity, hiding their work from reporters and observers in an attempt to conceal the secrets of flight. This was not the case. They had been free with information, sending complete descriptions of their work to Octave Chanute in numerous letters, inviting Chanute, George Spratt, Edward Huffaker, Augustus Herring, and others to the Kitty Hawk camps, and publishing articles in scientific and aeronautical journals.

Once they returned to Dayton in 1904 and 1905, they carried out their flights in full public view. Anyone from the neighborhood was free to stand and watch, while passengers on the traction cars could see all they wanted as they passed by. Reporters were invited out to Huffman Prairie on several occasions. Unfortunately, the weather prevented flights on most of those visits, and the papers soon lost interest.

The reports of their flights had a profound impact in Europe. Particularly

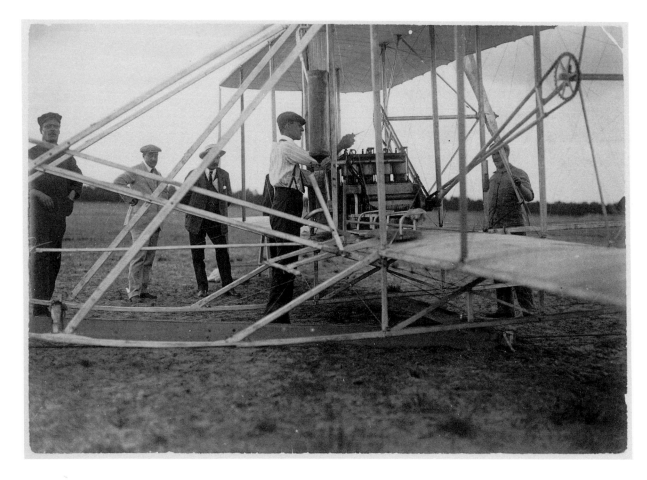

Plate 50. WILBUR ADJUSTING THE MOTOR, LE MANS, FRANCE, 1908

"The French newspapers and people have gone nearly wild over the demonstrations and are now as enthusiastic as they were skeptical before. You can scarcely imagine what a change there has been. We certainly cannot complain of the French newspapers during the past week. . . .They admit that we have completely distanced the French aviators and accept our former flights of 1903-04-05 without question. . . .The people of Le Mans are exceedingly friendly and proud of the fame it is giving their town. I am in receipt of bouquets, baskets of fruit etc. etc. almost without number. The men down at Bollée's shop have taken up a collection to buy me a testimonial of their affection. They say that I, too, am a workman" Wilbur Wright to Milton Wright, August 15, 1908.

Wright Photograph

in France, where aeronautical efforts had been languishing, aeronauts were galvanized by these stories sent to them by Chanute. Determined not to lose the race to perfect a practical flying machine, the French redoubled their efforts. Alberto Santos-Dumont, Gabriel Voisin, Louis Bleriot, and Henri Farman, among others, sought to surpass the Wrights by launching flying machines in the full glare of publicity. Working in relative obscurity back in Ohio, Will and Orv hesitated to go fully public with their Flyer.

This reluctance was due in part to the need to protect their patent rights. Fearing that the doctrine of "prior disclosure" might invalidate their claims to the wing-warping and rudder control system, they were waiting for a final verdict from the Patent Office. This finally came in 1906, but by then the brothers were deeply involved in complicated business negotiations with several governments and private syndicates. It would be almost two more years before they were at last ready to demonstrate the airplane to the public. As Wilbur wrote for the court:

> "We spent the next two years in building machines and making business arrangements for the exploitation of the patent. In 1908 we sold a machine to the United States government, and in the years 1908 and 1909 flights were made before the officials of the United States, at Washington, and before the rulers of England, France, Spain, Italy and Germany. Corporations were organized in several of these countries, including the United States, for the commercial exploitation of aeroplanes built under authority of the patent."

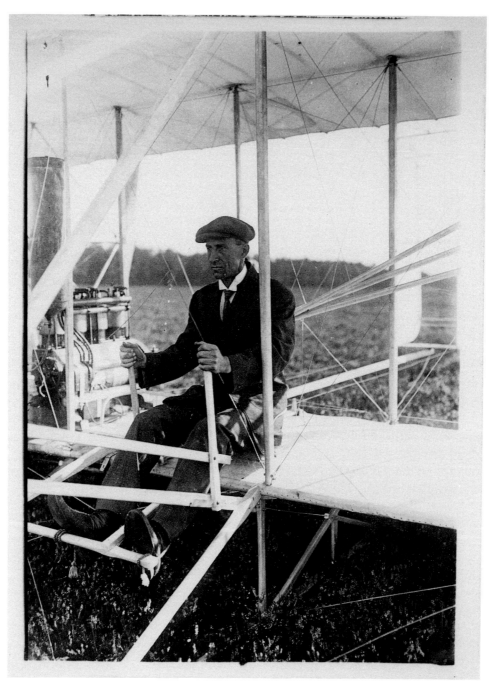

Plate 51.
WILBUR WITH HIS "FLYING
FACE," CAMP D'AUVOURS,
FRANCE

"I have become a sort of
popular hero in this
district, where everyone
seems to take pride in the
fact that we made our
flights here instead of near
Paris. We have even been
set to music, and everyone
is singing a song "Il vol" of
which I will send you a
copy as soon as I can get
one. You really can have no
comprehension of the
enthusiasm with which the
flights have been greeted
especially in France but
almost equally in the rest
of Europe" Wilbur Wright
to Katharine Wright,
August 22, 1908.

*M. Roland Company
Photograph, Paris, France*

In his deposition Wilbur passed rather hurriedly over what was an exciting time for the Wrights. Having decided in 1905 that they now had a practical airplane to market, the brothers made many fruitless attempts to interest the United States government in their invention. An almost comical series of letters passed between Dayton and Washington, as the Wrights attempted to convince the government that they had a practical, operable flying machine. The government kept responding that there was no money to spend on developing flying machines. At last, on February 10, 1908, the brothers broke through the bureaucratic wall and negotiated a contract for the sale of a "heavier-than-air flying machine" to the U. S. Army Signal Corps.

The contract required that before acceptance, the military Flyer pass a series of public trials for speed and duration of flight. To fulfill this requirement, Orville traveled in August 1908 to the cavalry training field at Fort Myer in Alexandria, Virginia. There, from September 3-16, 1908, he electrified official Washington with a series of spectacular flights. Then on September 17, the plane crashed, severely injuring Orville and killing his passenger, Lt. Thomas E. Selfridge. Orville took several months to recover from the broken bones suffered in this crash, and for the rest of his life he had recurring pain. By the next summer he was well enough to resume the interrupted trials, and from June 29-July 30, 1909, his new series of flights at Fort Myer more than satisfied the terms of the contract, and the first Air Force 1 began its duties as an army scouting and observation plane.

Wilbur was not idle while Orville was flying at Fort Myer. The Wrights had also negotiated sales of airplanes in France, and Wilbur sailed in May 1908 for Europe to pursue this line of business. He was offered the use of an automobile factory in Le

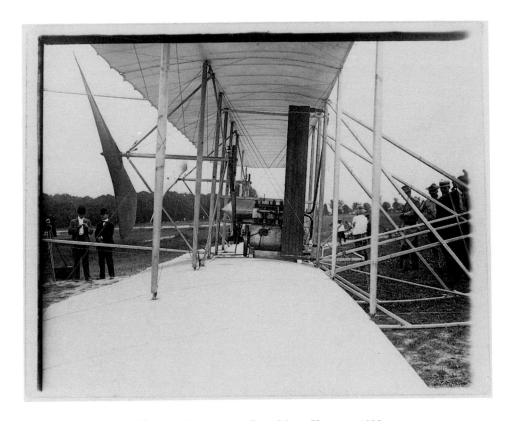

Plate 52. THE FLYER AT FORT MYER, VIRGINIA, 1908

In September, Orville went to Fort Myer, across the Potomac River from Washington, D. C., to begin test flights for the U. S. Army Signal Corps as required by the Wrights' contract with the army.

U. S. Army Signal Corps Photograph

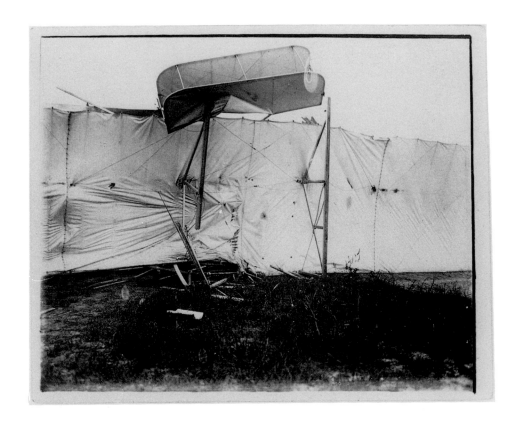

Plate 53. THE CRASH IN WHICH ORVILLE WAS BADLY INJURED AND LT. THOMAS E. SELFRIDGE KILLED, FORT MYER, SEPTEMBER 17, 1908

"Just after passing over the top of our building at a height which I estimate at 100 or 110 feet. . . .I heard (or felt) a light tapping in the rear of the machine. . . .I suppose it was not over two or three seconds from the time the taps were heard, till two big thumps, which gave the machine a terrible shaking, showed that something had broken. . . .Quick as a flash, the machine turned down in front and started straight for the ground. . . .Lieutenant Selfridge up to this time had not uttered a word though he. . . .turned once or twice to look into my face. But when the machine turned headfirst for the ground, he exclaimed "Oh! Oh!" in an almost inaudible voice" Orville Wright to Wilbur Wright, November 14, 1908.

U. S. Army Signal Corps Photograph

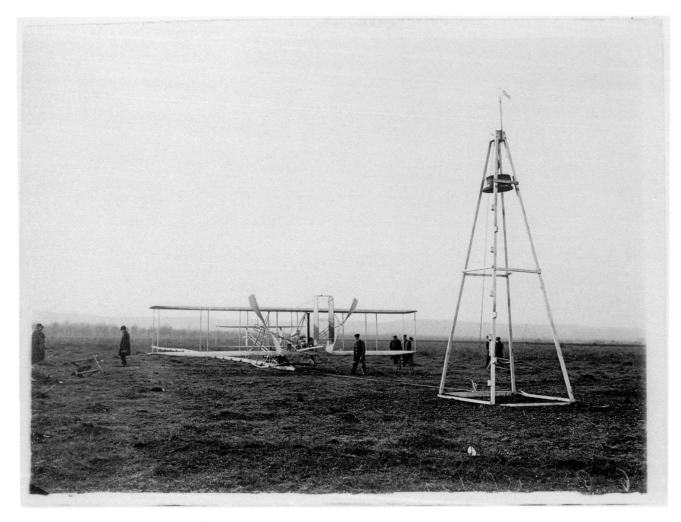

Plate 54. FLYER AND LAUNCHING DERRICK, PAU, FRANCE, 1909

The device, which never failed in thousands of starts, provided an extra safety
margin as a weight catapulted the plane on take-off.

Photographer Unknown

Mans owned by a wealthy aviation enthusiast, Léon Bollée. From June to August 1908, Wilbur carefully unpacked his Flyer from its crates and assembled it. On August 8, 1908, he made his first public flight at the Les Hunaudières race track at Le Mans. Initial French skepticism about the flying claims of this laconic Yankee turned to wild enthusiasm as Wilbur demonstrated a conclusive mastery of the flying art. After two weeks, Wilbur moved his flights to Camp d'Auvours, a military training field outside Le Mans. There, until December 31, 1908, he made a historic series of outstanding flights which earned him numerous awards and trophies.

In January 1909, seeking a warmer climate, Wilbur moved his operations to the resort town of Pau, near the Pyrenees mountains. Joined by Orville and Katharine, Wilbur continued his flights before the kings of England and Spain, celebrities, politicians, and society figures. He also established the world's first flight school at Pau, where French pilots were trained.

The Italians were also enthusiastic about aviation, and the Wrights saw another market for the airplane in Italy. From March 28-April 27, 1909, Wilbur demonstrated the Flyer and trained Italian pilots at Centocelle Field, near Rome. King Victor Emmanuel took pictures of the flights with his own camera.

Orville, too, was exposed to the European enthusiasm for flight. He went to Germany to fulfill yet another Wright contract. From August 19-October 15, 1909, he flew at Tempelhof Field near Berlin and Bornstedt Field near Potsdam. Greeted with excitement by the Kaiser and the royal family as well as hundreds of thousands of German citizens, Orville's record-setting flights were a fitting capstone to the Wrights' public careers as exhibition pilots.

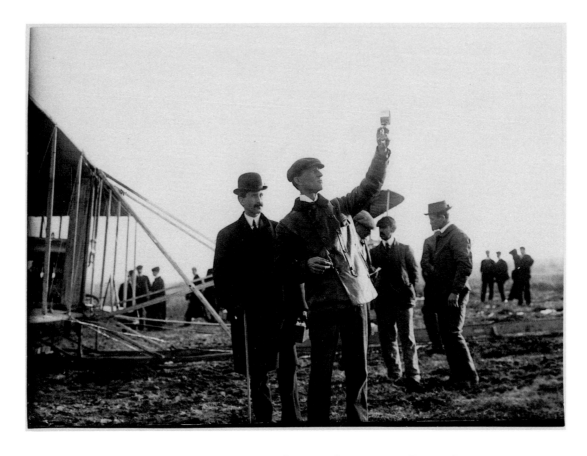

Plate 55. ORVILLE AND WILBUR (HOLDING ANEMOMETER), PAU, 1909

The anemometer, a hand-held device for measuring the speed of the wind, was a necessary
instrument in the early days of flight. Orville, to the left, is still using a cane because of
his injuries from the 1908 Fort Myer crash.

Photographer Unknown

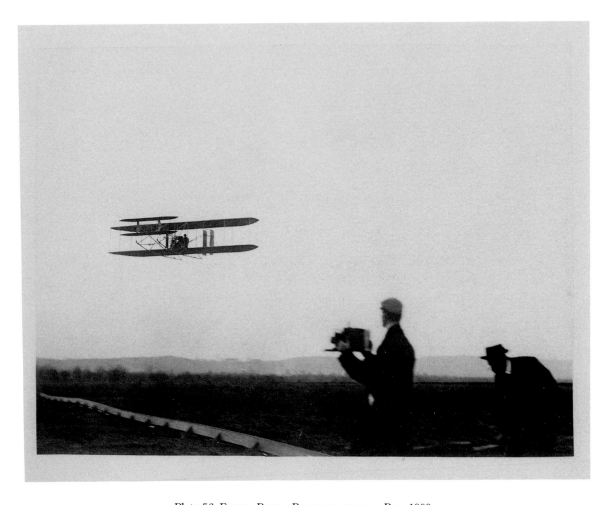

Plate 56. FLYING PAST A PHOTOGRAPHER AT PAU, 1909

At Pau, Wilbur began training French pilots and established the world's first formal training
school for pilots. Here he flies past as a man with a camera captures the scene.

J. Callizo Photograph, Pau, France

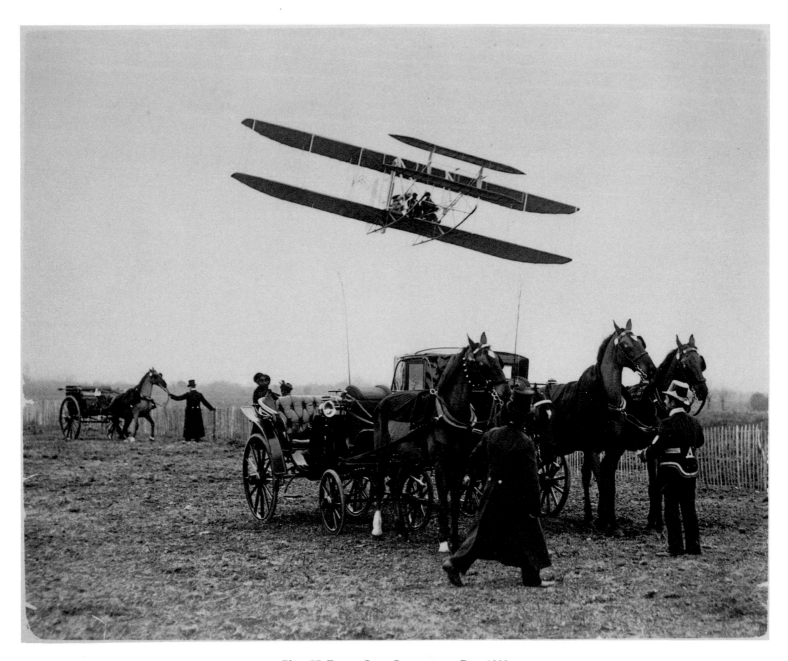

Plate 57. FLYING OVER CARRIAGES AT PAU, 1909

"For several weeks we have been having visits from a number of distinguished visitors. Mr. Balfour the
former prime minister of England was here a couple of weeks ago. Then the King of Spain made a special
trip to see us. . . .crowds of people come out every day and visitors flock there from all parts of Europe"
Wilbur Wright to Milton Wright, March 1, 1909.

Photographer Unknown

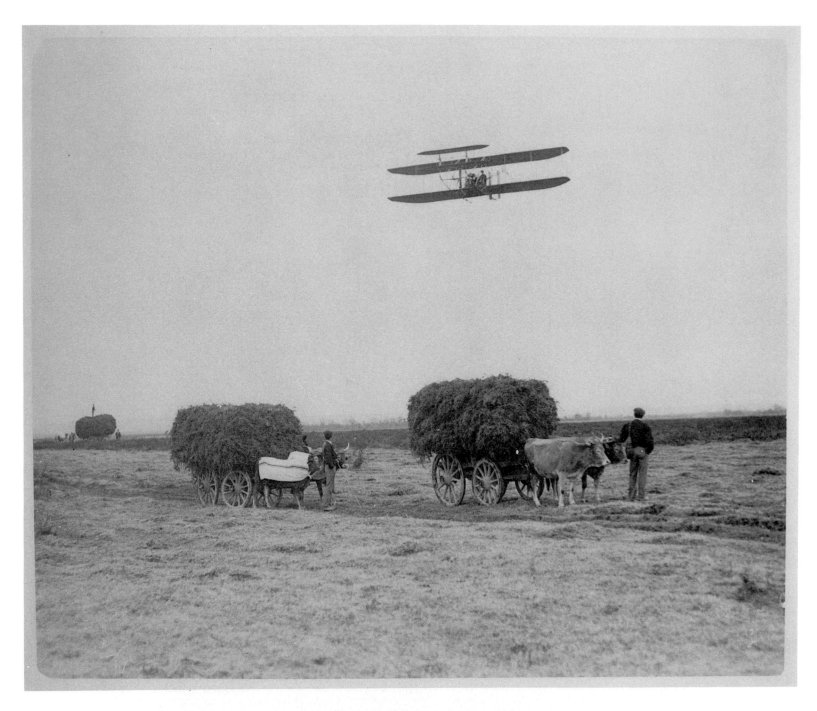

Plate 58. FLYING OVER OX CARTS AT PAU, 1909

Photographer Unknown

87

Plate 59. Mr. Speakman, Orville, Katharine, and C. S. Rolls Watching Wilbur Flying at Pau, 1909

Photographer Unknown

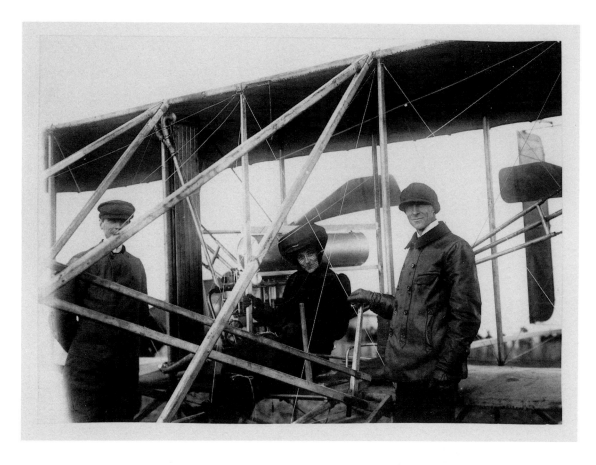

Plate 60. Count and Countess De Lambert with Wilbur, Preparing for a Flight, Pau, 1909

Photographer Unknown

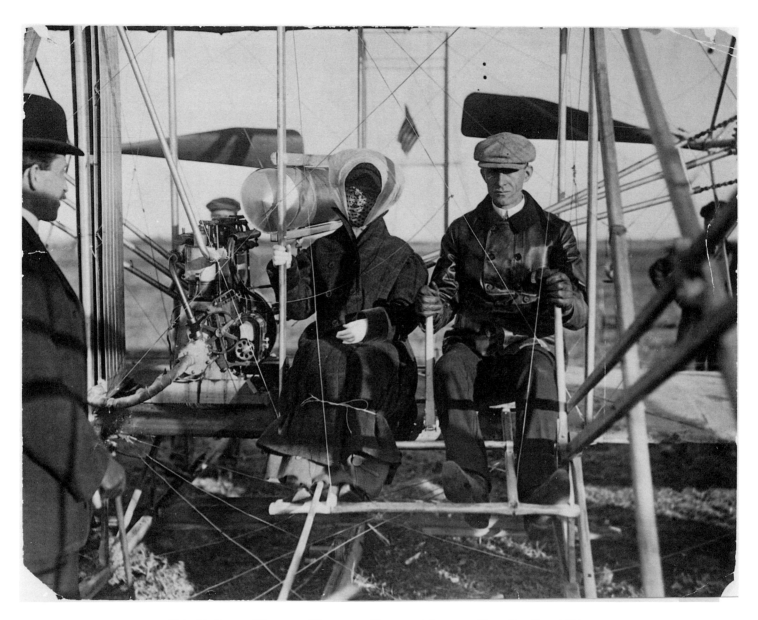

Plate 61. ORVILLE WATCHING WILBUR AND KATHARINE ABOUT TO TAKE OFF, PAU, 1909

On February 15, 1909, Katharine made her first flight as a passenger, with Wilbur at the controls. Early women flyers were obliged to tie their voluminous skirts with string to prevent an embarrassing display, thus giving rise to the short-lived fashion of the "hobble skirt."

Photographer Unknown

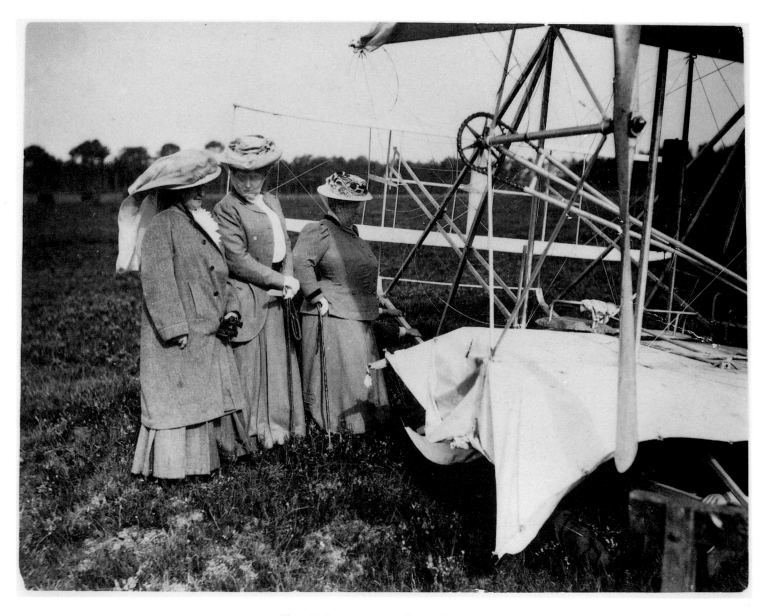

Plate 62. INSPECTING THE FLYER, PAU, 1909

Illustrations Bara 12 photograph

With apologies
to Mr. Wilbur Wright.
08.

Plate 63. FRENCH SILHOUETTE OF WILBUR, 1908

Plate 64. FRENCH CARICATURE OF WILBUR, 1908

The cartoons and drawing of Wilbur are samples of the many popular expressions of sentiment in France during the winter of 1908-09.

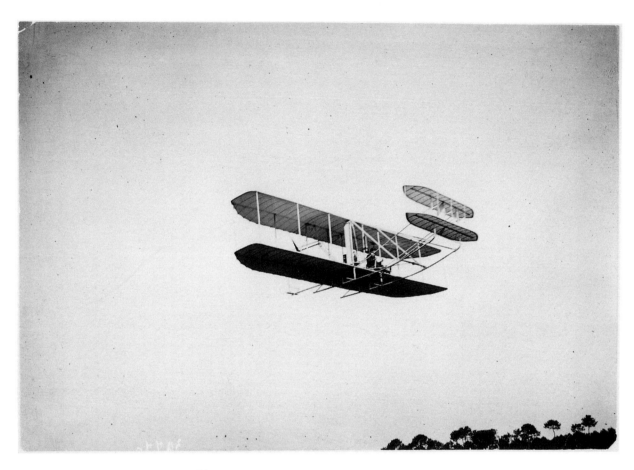

Plate 65. WILBUR FLYING AT LE MANS, FRANCE, 1908

Photographer Unknown

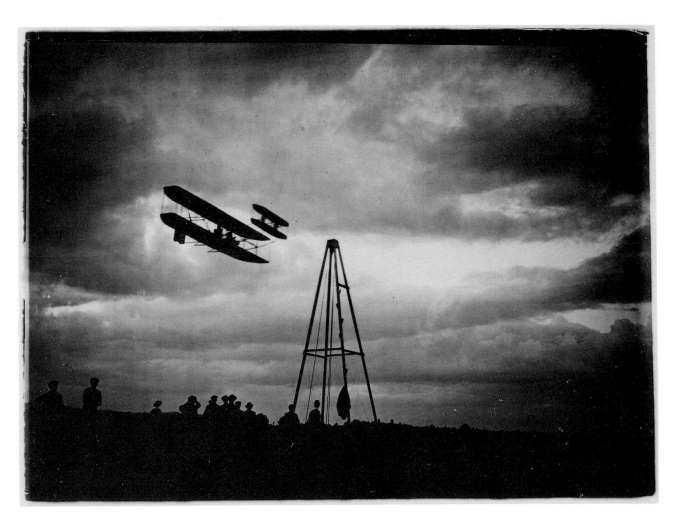

Plate 66. WILBUR FLYING INTO THE SUNSET, LE MANS, 1908

Cliché J. Thezard photograph, Paris, France

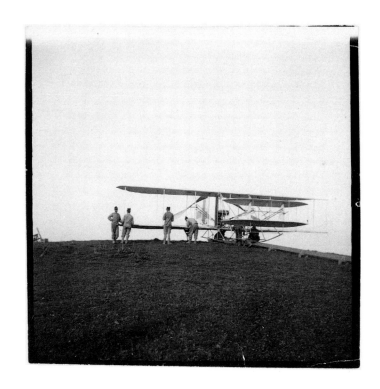

Plate 67. WORKING ON THE LAUNCHING TRACK, CENTOCELLE, ITALY, 1909

"The grounds for flights had not been fixed when I arrived but finally the place near the fort at Centocelle, to the southeast of Rome, has been settled upon. It is a very good place, flat but not quite level. . . .The view over the campagna toward Frascati is very beautiful. The town is situated on the slope of the Alban Mountains" Wilbur Wright to Orville Wright, April 4, 1909.

Photographer Unknown

Plate 68. ORVILLE AND WILBUR WITH AN UNIDENTIFIED WOMAN, CENTOCELLE, 1909

Photographer Unknown

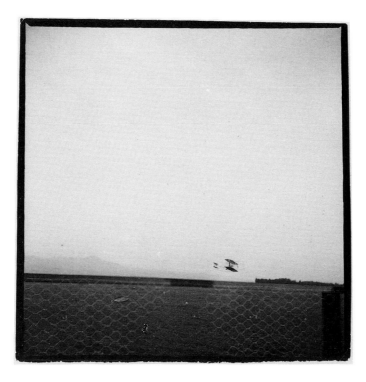

Plate 69. DISTANT VIEW OF THE FLYER, CENTOCELLE, 1909

Photographer Unknown

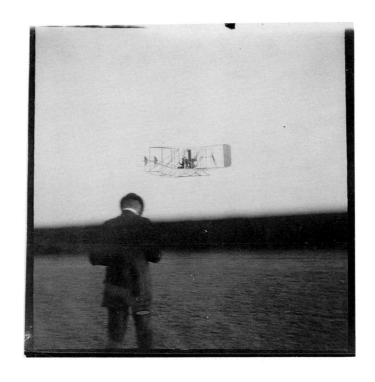

Plate 70. PHOTOGRAPHING THE FLYER ALOFT, CENTOCELLE, 1909

The airplane in flight soon became a popular subject for photographers.

Photographer Unknown

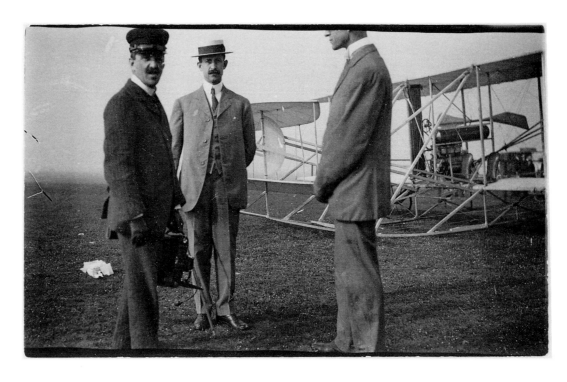

Plate 71. KING VICTOR EMMANUEL III WITH ORVILLE AND WILBUR AT CENTOCELLE, 1909

The king was an enthusiastic amateur photographer and brought his camera to
the public flying demonstrations.

Photographer Unknown

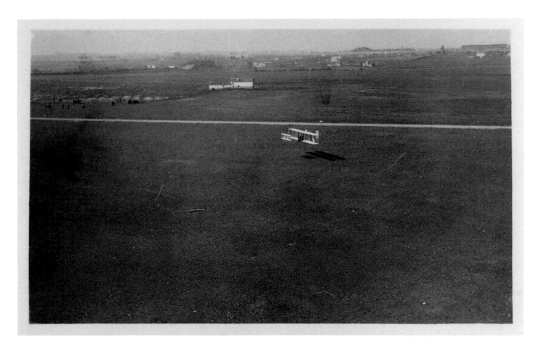

Plate 72. Photographed from a Balloon, the First Picture of a Flying Machine
Taken from the Air, Centocelle, 1909

Hart O. Berg photograph

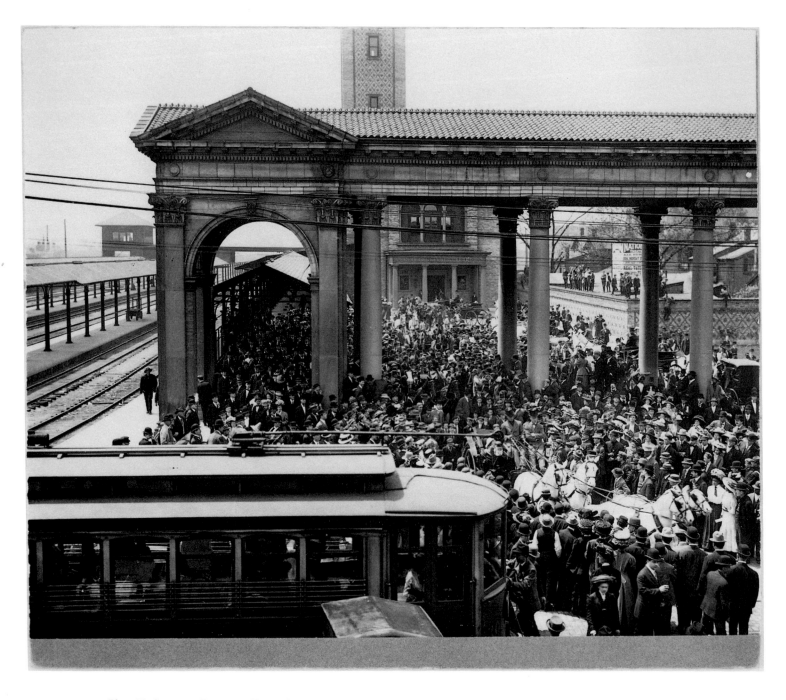

Plate 73. Scene at Dayton's Union Station at the Start of the Dayton Homecoming Celebration, June 1909

Andrew S. Iddings photograph, Dayton

Plate 74. HORSE-DRAWN CARRIAGE PARADES THE WRIGHTS DOWN DAYTON'S MAIN STREET, JUNE 17, 1909

Andrew S. Iddings photograph, Dayton

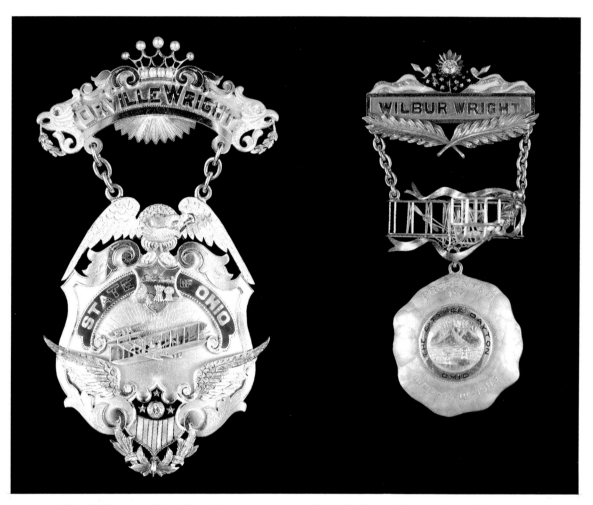

Plate 75. STATE OF OHIO GOLD MEDAL
PRESENTED TO ORVILLE WRIGHT BY
GOVERNOR JUDSON HARMON, DAYTON,
JUNE 18, 1909

Plate 76. CITY OF DAYTON GOLD MEDAL
PRESENTED TO WILBUR WRIGHT BY
MAYOR EDWARD E. BURKHART, DAYTON,
JUNE 18, 1909

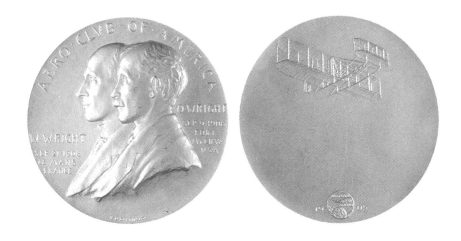

Plate 77. AERO CLUB OF AMERICA GOLD MEDAL PRESENTED TO THE WRIGHTS BY
PRESIDENT WILLIAM HOWARD TAFT AT THE WHITE HOUSE ON JUNE 10, 1909

Plate 78. THE LANGLEY MEDAL PRESENTED TO THE WRIGHTS BY CHIEF JUSTICE MELVILLE W. FULLER
ON BEHALF OF THE SMITHSONIAN INSTITUTION ON FEBRUARY 10, 1910

Plate 79. MEDAL OF THE FRENCH LEGION
OF HONOR PRESENTED TO THE WRIGHTS
BY THE FRENCH CONSUL GENERAL ON
NOVEMBER 5, 1909, IN NEW YORK CITY

Plate 80. AMERICAN MEDAL OF MERIT

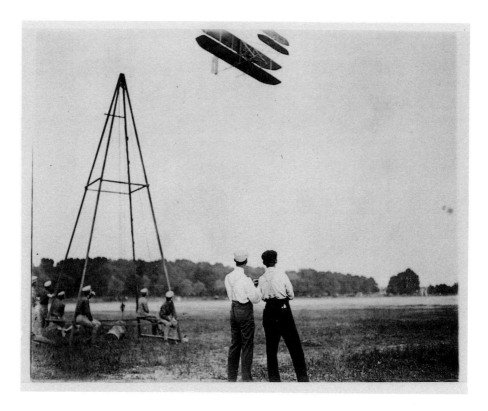

Plate 81. WILBUR AND CHARLIE TAYLOR WATCHING ORVILLE FLYING, FORT MYER, VIRGINIA, 1909

Charles E. Taylor was the Wrights' mechanic and the man who built the first practical airplane motor, the engine for the 1903 Flyer.

C. H. Claudy photograph, Washington, D. C.

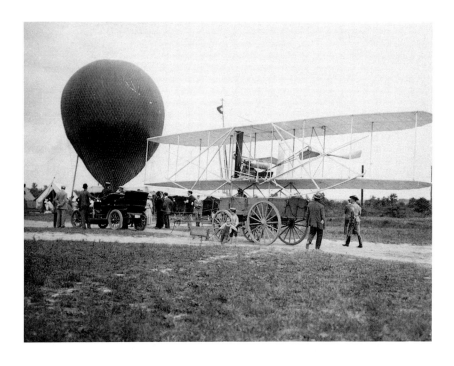

Plate 82. FOUR MODES OF TRANSPORTATION: AIRPLANE, FREE BALLOON, ARMY WAGON, AND AUTOMOBILE, FORT MYER, 1909

C. H. Claudy photograph, Washington, D. C.

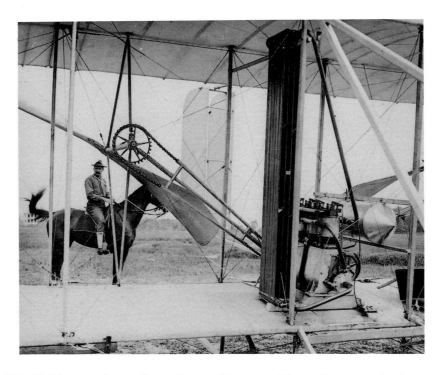

Plate 83. MOUNTED SIGNAL CORPS OFFICER GUARDS THE WRIGHT FLYER UPON ITS ARRIVAL
AT FORT MYER, 1909

C. H. Claudy photograph, Washington, D. C.

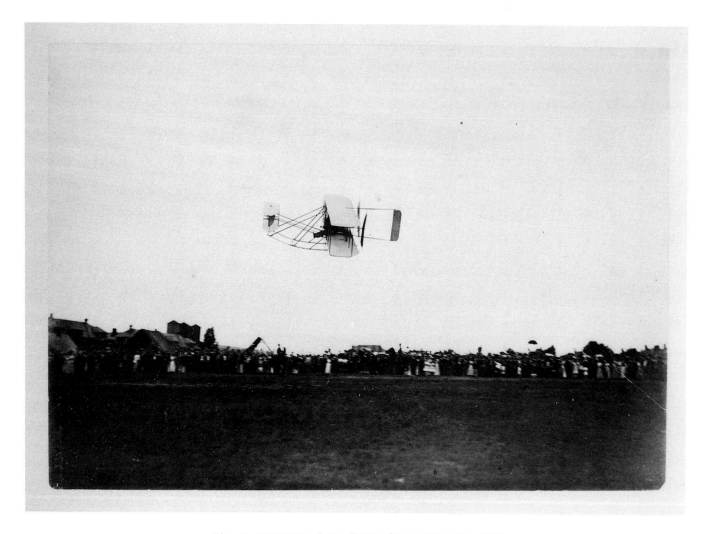

Plate 84. FORT MYER SPEED TRIALS, ORVILLE PILOTING, 1909

Orville went back to Fort Myer in July 1909 for the trials to satisfy the army contract. The plane remained aloft for one hour while carrying two people, and completed the required course at an average speed of 42.583 miles per hour.

C. H. Claudy photograph

Re order 3619

WAR DEPARTMENT,

OFFICE OF THE CHIEF SIGNAL OFFICER,

WASHINGTON.

February 28, 1908.

Wright Brothers,
 Dayton, Ohio.

Gentlemen:

 I am directed by the Chief Signal Officer of the Army to forward herein contract in completed form for one heavier-than-air flying machine under proposal No. 203, order No. 3619.

 This copy is for your files.

 Very respectfully,

 Captain, Signal Corps, U. S. A.,
 Disbursing Officer.

1 Incl.

In replying address.
Chief Signal Officer of the Army.
Washington, D. C.

Disbursing Division.

Plate 85.
COVER LETTER THAT ACCOMPANIED THE ARMY SIGNAL CORPS CONTRACT FOR THE FIRST SALE OF AN AIRPLANE TO THE U. S. GOVERNMENT, 1908

Plate 86. CROWDS OF CHILDREN AND ADULTS WATCH THE FLIGHTS AT TEMPELHOF FIELD,
BERLIN, GERMANY, 1909

Photograph commissioned by August Scherl, owner, Lokal-Anzeiger newspaper, Berlin, Germany

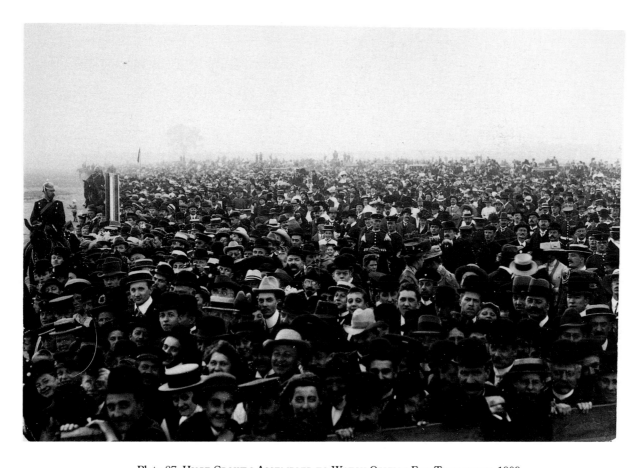

Plate 87. HUGE CROWDS ASSEMBLED TO WATCH ORVILLE FLY, TEMPELHOF, 1909

"It has pleased the people here very much that I was able to fly every day in spite of the wind, which
on only two days was as low as 3 meters per second, most of the time 6 to 9 meters, one day, they say,
12 meters" Orville Wright to Wilbur Wright, September 23, 1909

Photograph commissioned by August Scherl

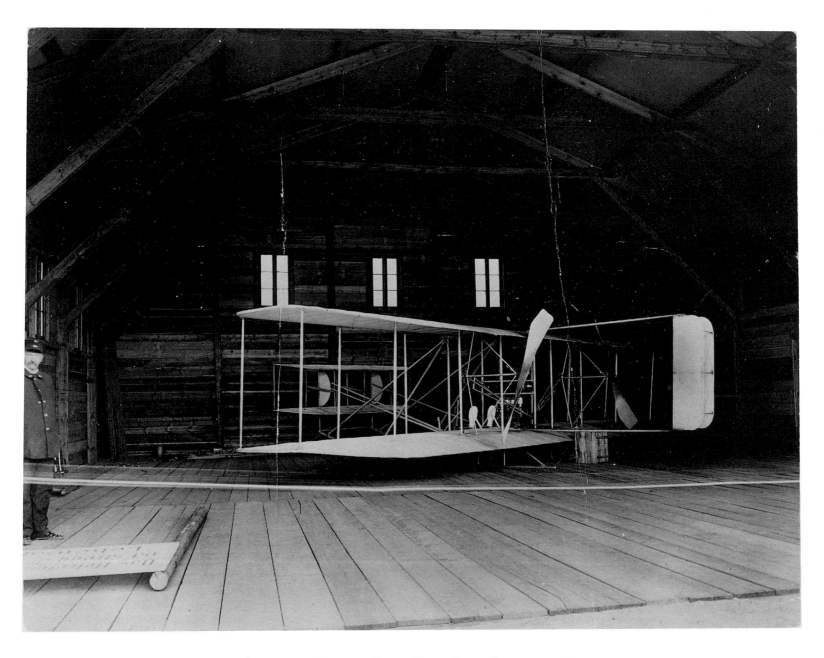

Plate 88. FLYER RESTING IN HANGAR UNDER GUARD, TEMPELHOF, 1909

Photograph commissioned by August Scherl

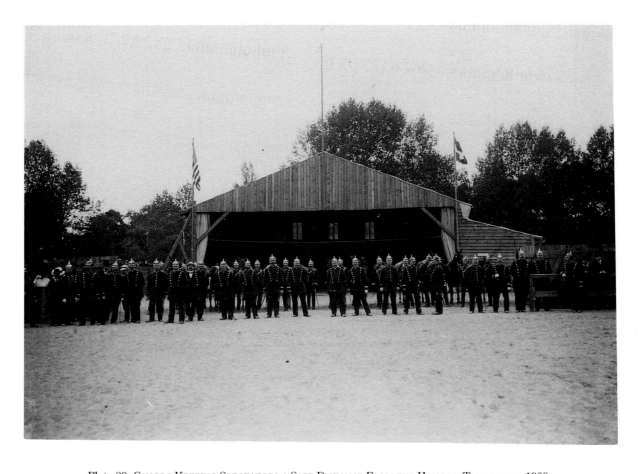

Plate 89. GUARDS KEEPING SPECTATORS A SAFE DISTANCE FROM THE HANGAR, TEMPELHOF, 1909

Photograph commissioned by August Scherl

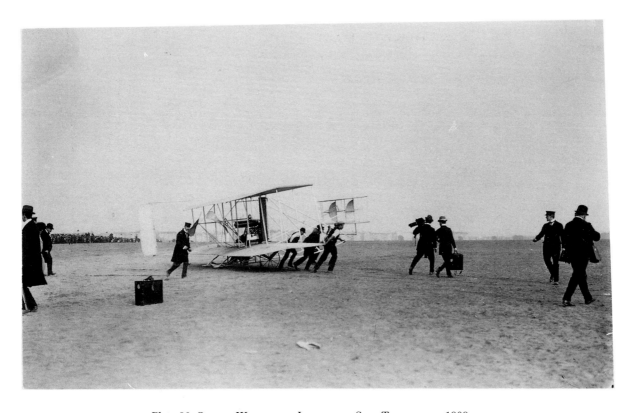

Plate 90. ON THE WAY TO THE LAUNCHING SITE, TEMPELHOF, 1909

Photograph commissioned by August Scherl

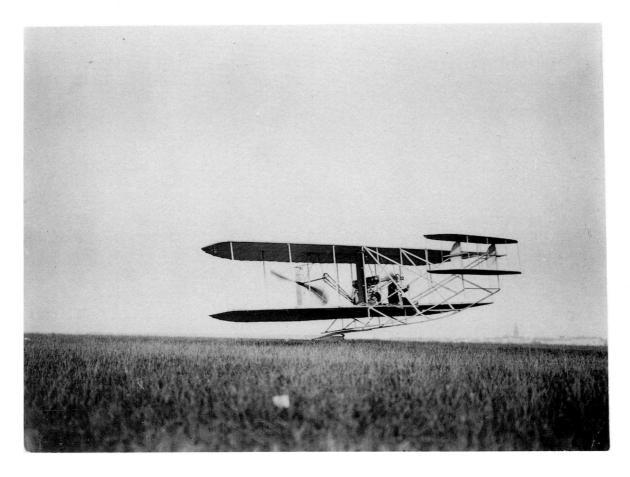

Plate 91. FLYER JUST AFTER LAUNCHING, TEMPELHOF, 1909

"I have never passed through so many and such severe whirlwinds as in the flights here. But they were usually in certain parts of the field and I could keep out of the worse of them if I chose. I would be flying along very nicely when of a sudden the machine would begin to quiver and on looking at the tape I would see it swerve to one side at an angle of over 45 degrees and then in a few seconds, without my making any change with the rudder, it would swing an equal amount to the opposite side" Orville Wright to Wilbur Wright, September 23, 1909.

Photograph commissioned by August Scherl

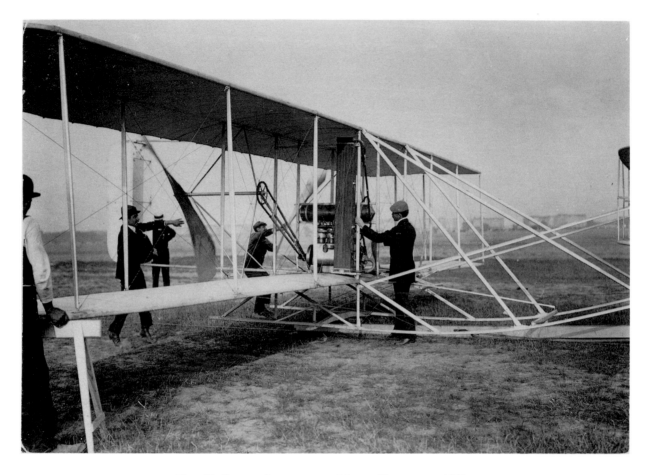

Plate 92. ORVILLE ADJUSTING THE MOTOR, TEMPELHOF, 1909

"The Crown Prince called me up on the telephone again yesterday. . . .I have now had a half dozen or more conversations with the Crown Prince on the telephone. We are getting quite chummy! He says he doesn't want to miss getting a ride. Everyone tells me that I had better get the consent of the Emperor before taking him, as there might otherwise be trouble" Orville Wright to Wilbur Wright, September 23, 1909.

Photograph commissioned by August Scherl

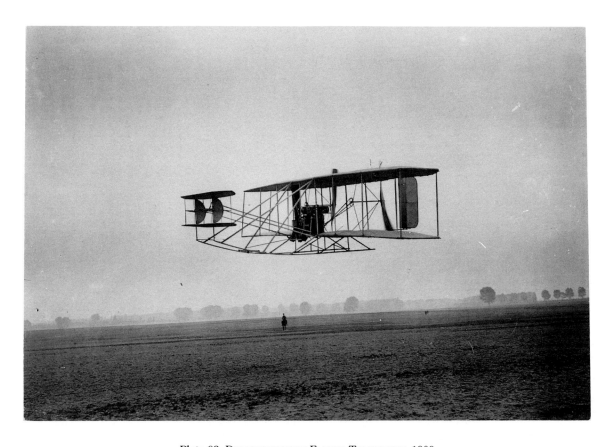

Plate 93. DEMONSTRATION FLIGHT, TEMPELHOF, 1909

"In the early flights the machine was jerked from under me a number of times, and I would find myself sitting 5 or 6 inches up the back of the seat. . . .As I try to hold myself in the seat by pushing myself tight against the back I rode for quite a distance before I slipped down to the seat. I am going to tie myself on the seat with string. Latham always straps himself on his seat" Orville Wright to Wilbur Wright, September 23, 1909.

Photograph commissioned by August Scherl

Plate 94. EXCITED CROWDS RUSHING TO GET CLOSER TO THE ACTION, TEMPELHOF, 1909

"The little crown prince and his small brother (aged 4 and 2 years) came out to see a flight yesterday afternoon. They came in grand style with a governess and two big footmen! Capt. Engelhardt and I made a flight for them — or rather started on one — and when up about eight feet from the ground the engine suddenly stopped. Capt. did not start down soon enough. I seized the lever, but too late to make a good landing. One front skid was cracked - the first break we have had since I have been here. We discovered that a cylinder had blown off" Orville Wright to Wilbur Wright, October 8, 1909.

Photograph commissioned by August Scherl

Plate 95. ORVILLE ESTABLISHING A WORLD ALTITUDE RECORD OF 902 FEET, BORNSTEDT, GERMANY, SEPTEMBER 30, 1909

The white "x" was made by the photographer. It documents a location significant only to him.

Photographer Unknown

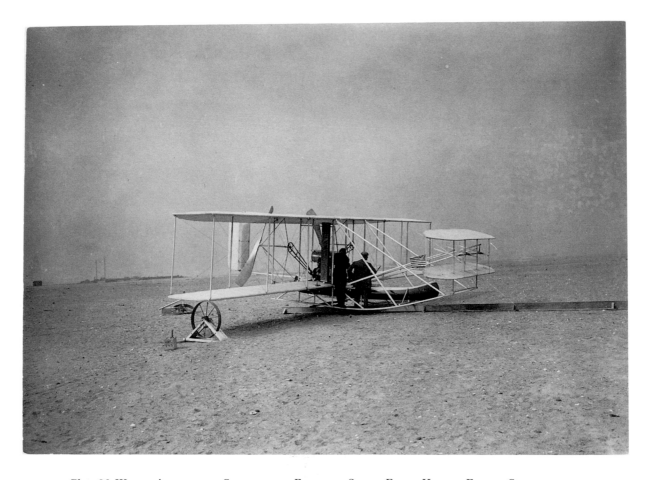

Plate 96. WILBUR ATTACHING A CANOE TO THE FLYER AS A SAFETY FLOAT, HUDSON-FULTON CELEBRATION, NEW YORK CITY, 1909

"I have been here about a week and have the machine about ready to fly. In order to go over the water I will fit a canoe under the machine, but the motor seems in good shape and I do not expect to come down involuntarily. We have a good place for starting and landing on Governor's Island" Wilbur Wright to Katharine Wright, September 26, 1909.

J. H. Hare photograph, Collier's Weekly, New York City

FLYING BECOMES A BUSINESS

———◆———

THEIR TRIUMPHAL FLIGHTS IN Europe before kings and commoners alike, as well as their successful negotiations with the United States government, at last brought the Wright brothers a measure of fame and recognition in their hometown. Dayton tried to make up for the years when the flights at Huffman Prairie had been largely ignored. For two days in June 1909, the Wright homecoming celebration occupied center stage in the Miami Valley city. Brought from the railroad station to their modest home on Hawthorn Street in a carriage drawn by white horses, serenaded by bands, honored by a parade down Main Street, and awarded gold medals by city and state, the modest "bishop's boys" at last received the recognition they treasured best, that of their friends and neighbors.

With their patent seemingly secure and their fame established beyond question, Wilbur and Orville seemed prepared to settle down after their labors. They had always asserted that they had not invented the airplane in order to get rich or to become big businessmen. The challenge of the intellectual game, the excitement of invention, was always the principal motivation for their work. Now it seemed that a modest fortune might be theirs as well.

With contracts secured for the sale of Wright Flyers to the United States government and to several European purchasers, the Wrights formally went into business. On November 22, 1909, they incorporated the Wright Company with a capital stock of $1 million and a gilt-edged board of directors that included Cornelius Vanderbilt, August Belmont, and the publisher Robert Collier. The Wrights received $100,000 in cash outright, 40 percent of the stock, and a 10 percent royalty on all planes sold. Ground was soon broken for a Dayton factory, which opened for business in

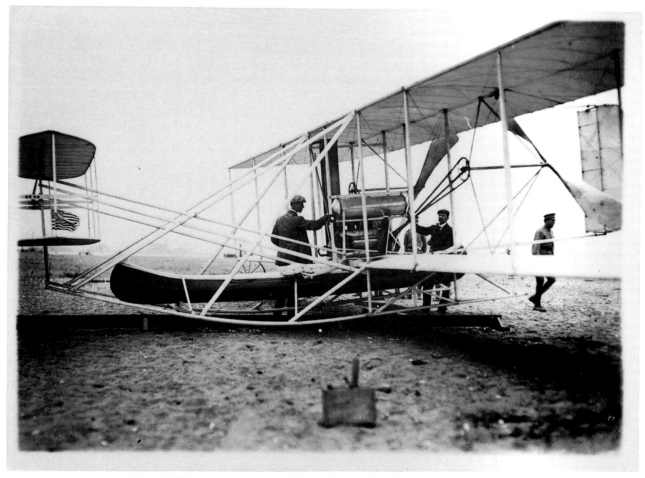

Plate 97. Wilbur Adjusting the Motor Before His Statue of Liberty Flight,
Hudson-Fulton Celebration, 1909

"On Wednesday I made a few trips. The first being around Governor's Island along the Brooklyn
shore, the Battery and back to the Island. In the second I went out to Bedloe's Island and rounded the
Statue of Liberty. The third late in the evening was made in a rather strong wind merely because I had
half promised to make a flight and a number of people had made special trips to see it"
Wilbur Wright to Milton Wright, October 1, 1909.

Paul Thompson photograph, New York City

November 1910. For a time it was the largest airplane factory in the world, with a capacity to produce four planes a month and almost a year's backlog of orders.

As a spur to their business ventures and an advertisement for their product, the Wrights became active participants in the wave of aviation meets and exhibitions which swept the country. Flying was the latest craze, and the public wanted to see for themselves what before they had only read about in press reports. As early as October 1909, Wilbur electrified New Yorkers by his flights at the Hudson-Fulton celebration.

Commemorating Hudson's seventeenth-century voyages and Fulton's invention of the steamboat, this celebration featured Wilbur flying up the Hudson River to Grant's Tomb and also circling the Statue of Liberty. Strapping a canoe under the Flyer for safety, Wilbur made headlines across the country.

Exhibition teams were organized to demonstrate Flyers at fairs, racetracks, and grandstands. People flocked to airshows at Belmont Park in New York, at the Indianapolis Speedway, and in dozens of other settings. At the Belmont Park show the Wrights introduced the Baby Grand, which had a 60 horsepower engine and was capable of speeds higher than 70 miles per hour. It was the odds-on favorite to win the speed contests until a connecting rod broke before the race. Young daredevils with an appallingly short life expectancy raced one another, pushed to greater and greater altitudes and higher speeds, looped the loop, and spiraled to earth.

The Wright Company exhibition team needed a training place in a climate warmer than Dayton's where they could educate pilots and demonstrate flying. They located in Montgomery, Alabama, on a site that would later become Maxwell Air Force Base. Another Wright flying school operated for a time in College Park, Maryland.

Plate 98. MORE THAN ONE MILLION PEOPLE WITNESSED WILBUR'S FLIGHT AROUND THE STATUE
OF LIBERTY, HUDSON-FULTON CELEBRATION, SEPTEMBER 29, 1909

Photographer Unknown

Unhappily for the Wrights, their successes in flight and in business were to be overshadowed for some years by a series of bitter disputes about their patent rights. The patent granted in 1906 was very broad, covering the system of control using movable wing tips in conjunction with a movable tail or rudder to control the stability of a flying machine. This system is fundamental to all modern aircraft control. Broadly construed, the Wright patent gave the Wrights a monopoly on all aircraft built.

Naturally, other aeronauts resented and sought to evade the patent restrictions. Chief among them was Glenn Curtiss, who became the Wrights' target in the lawsuit *Wright Company v. Herring Curtiss Company and Glenn H. Curtiss.* The Wrights themselves were harmed most by the proliferation of lawsuits and countersuits. The endless court proceedings drained their creative energies, left them frustrated and bitter, and drew their attention away from aeronautical research at a crucial time. Leadership in aeronautical innovation passed to other hands.

In January 1910, a federal judge ruled in favor of the Wrights, holding that their patent covered virtually any device then in use for controlling aerial stability. The case was overturned on appeal, and that verdict, in turn, was appealed by the Wrights. The hearings and trials stretched on for years. Wilbur, a superb witness whose eloquent testimony did much to build the Wright case, suffered in both body and mind as the litigation dragged on. A letter of his to a Frenchman, Hévésy, written January 25, 1912, perhaps expresses his feelings most eloquently:

"It is much more pleasant to go to Kitty Hawk for
experiments than to worry over lawsuits. We had hoped in

Plate 99. LAPEL BADGE WORN BY WILBUR DURING HIS
HUDSON-FULTON FLIGHTS, 1909

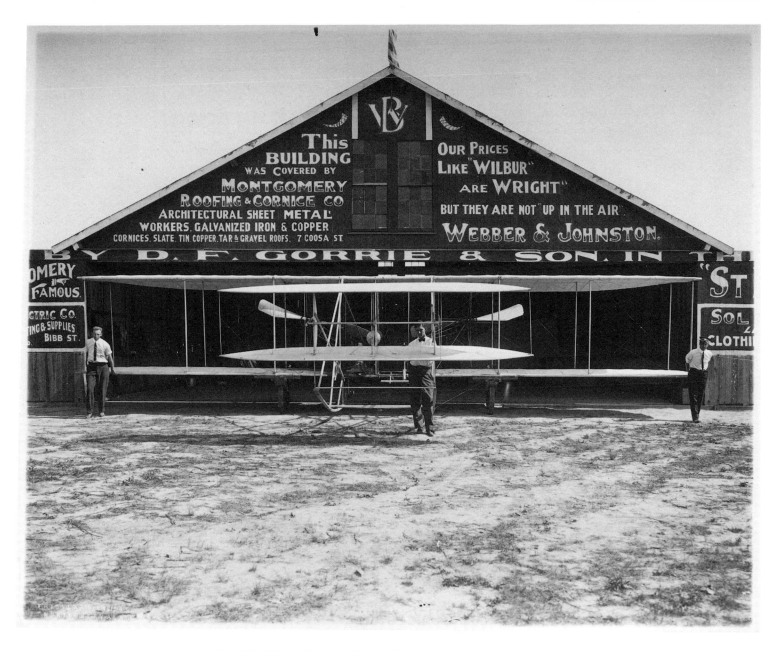

Plate 100. WRIGHT COMPANY FLYING SCHOOL, MONTGOMERY, ALABAMA, 1910

"We have been having a good deal of wind since my return so that I have done but little teaching. About half past six Friday night the wind quieted down so that I allowed Brookins to run the machine. He did pretty well in whirl winds, but in certain parts of the field we run into down trends of air in which he stalls the machine in trying to keep up. This is the greatest trouble he has. . . .Two of the boys borrowed money of me today. They say their checks do not come till a week after they are due. If Russell can't pay them on time tell him to send me some money so I can" Orville Wright to Wilbur Wright, April 24, 1910.

Tressler's Studio photograph, Montgomery, Alabama

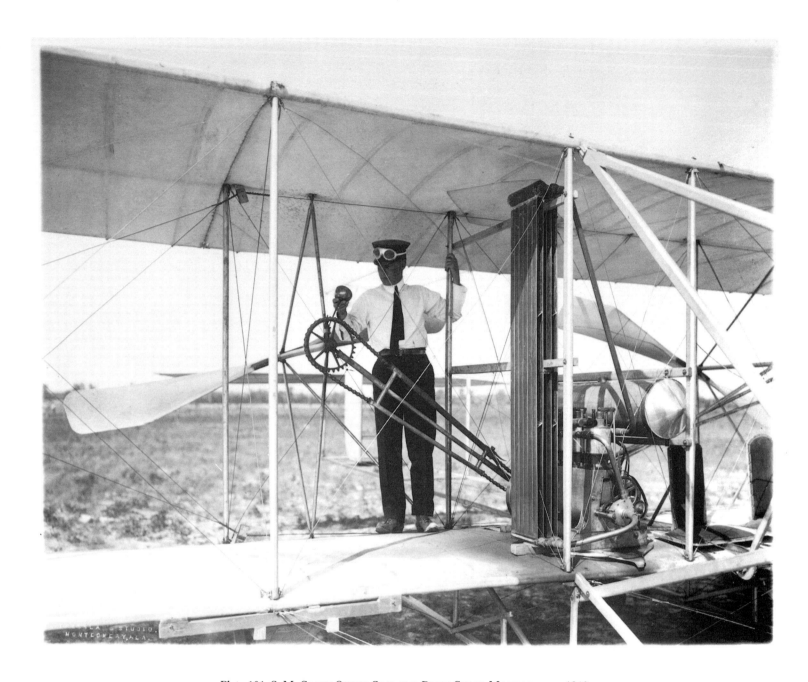

Plate 101. S. M. Crane Oiling Gear and Drive Chain, Montgomery, 1910

Tressler's Studio photograph, Montgomery, Alabama

to satisfy our needs and then devote our time to science, but the jealousy of certain persons blocked this plan, and compelled us to rely on our patents and commercial exploitation. We wished to be free from business cares so that we could give all our time to advancing the science and art of aviation, but we have been compelled to spend our time on business matters instead during the past five years. When we think what we might have accomplished if we had been able to devote our time to experiments, we feel very sad, but it is always easier to deal with things than with men, and no one can direct his life entirely as he would choose."

By the time these words were written, Wilbur's life was drawing to its end. Wearied and harassed, he was easy prey to typhoid fever in the spring of 1912. Rallying and then failing, he lingered for almost a month before dying on May 30, at the age of forty-five. He was laid to rest in the family plot in Dayton's Woodland Cemetery beside his mother. Perhaps Wilbur's best epitaph is his father's diary entry:

"This morning at 3:15, Wilbur passed away. . . .a short life, full of consequences. An unfailing intellect, imperturbable temper, great self-reliance and as great modesty, seeing the right clearly, pursuing it steadily, he lived and died."

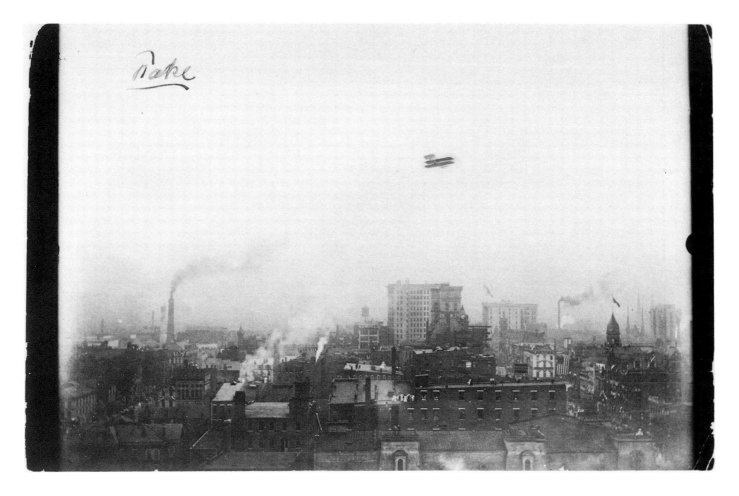

Plate 102. AIRPLANE IN FLIGHT OVER DAYTON, LABELED "FAKE" BY ORVILLE, 1910

The Wrights made numerous flights in the vicinity of Dayton but never made a documented flight
over the city. Many amateur photographers retouched photographs
in later years to show flights that had never been made.

Photographer Unknown

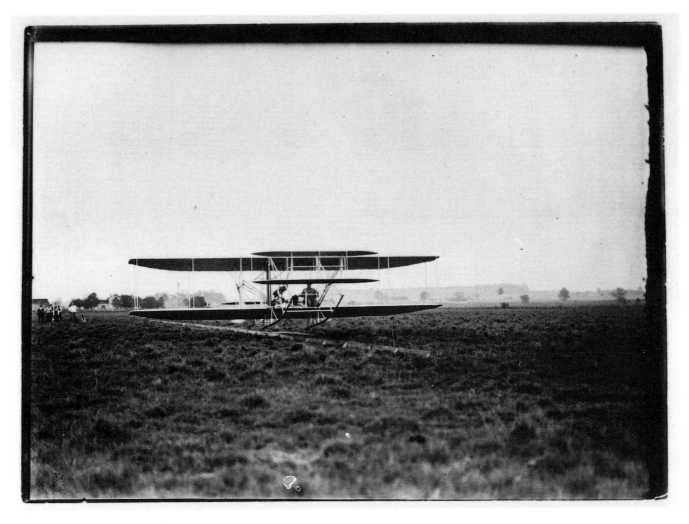

Plate 103. MORE FLIGHT TESTING, HUFFMAN PRAIRIE (SIMMS STATION), 1910

Wright Photograph

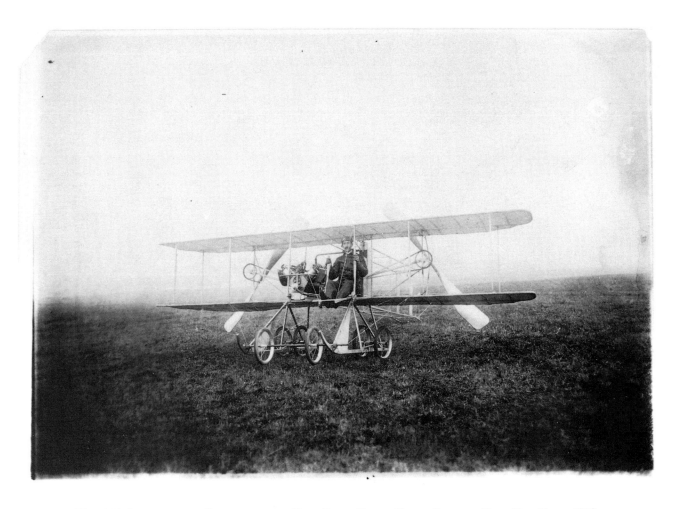

Plate 104. ORVILLE AT THE CONTROLS OF THE BABY GRAND RACING PLANE, BELMONT PARK, NEW YORK, 1910

"I have been studying out a plan for transferring the rudder to the rear, and it works out very well on paper. I think we should make a trial of something of the kind. . . .With front wings about the size of the U. S. machine and a 50 ft. horizontal rudder we would have a very nice. . . .machine and with special tips a racer that would go 55 miles an hour. We would probably have to start on wheels to avoid an unduly long track" Wilbur Wright to Orville Wright, September 11, 1909.

Wright Photograph

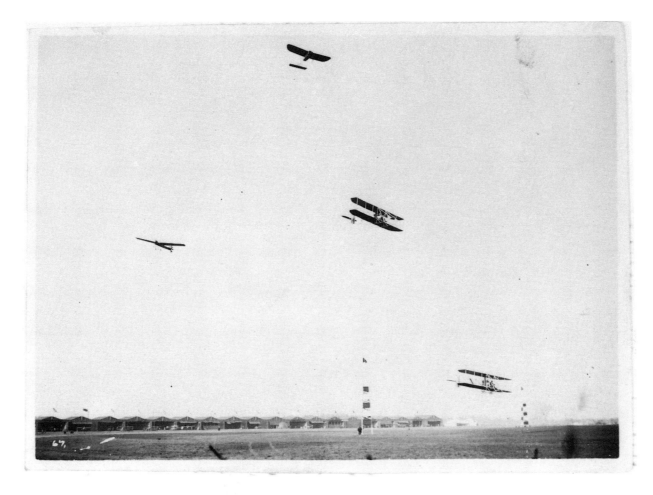

Plate 105. ORVILLE AND SEVERAL OTHER WRIGHT COMPANY EXHIBITION PILOTS FLY AT BELMONT PARK, 1910

"I think it would be a mistake to get up a racer with less speed than 70 miles. We ought to beat them badly if we go into it at all" Wilbur Wright to Orville Wright, September 26, 1909.

Photographer Unknown

135

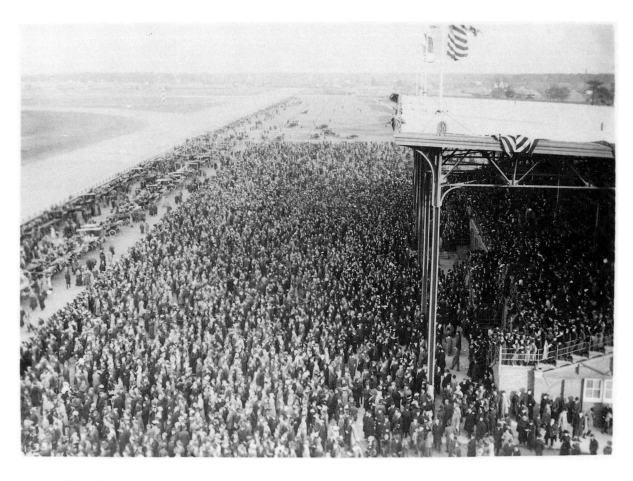

Plate 106. CROWDS AT BELMONT PARK WATCH WRIGHT COMPANY PILOT RALPH JOHNSTONE SET A WORLD ALTITUDE RECORD OF 9,714 FEET, OCTOBER 31, 1910

Photographer Unknown

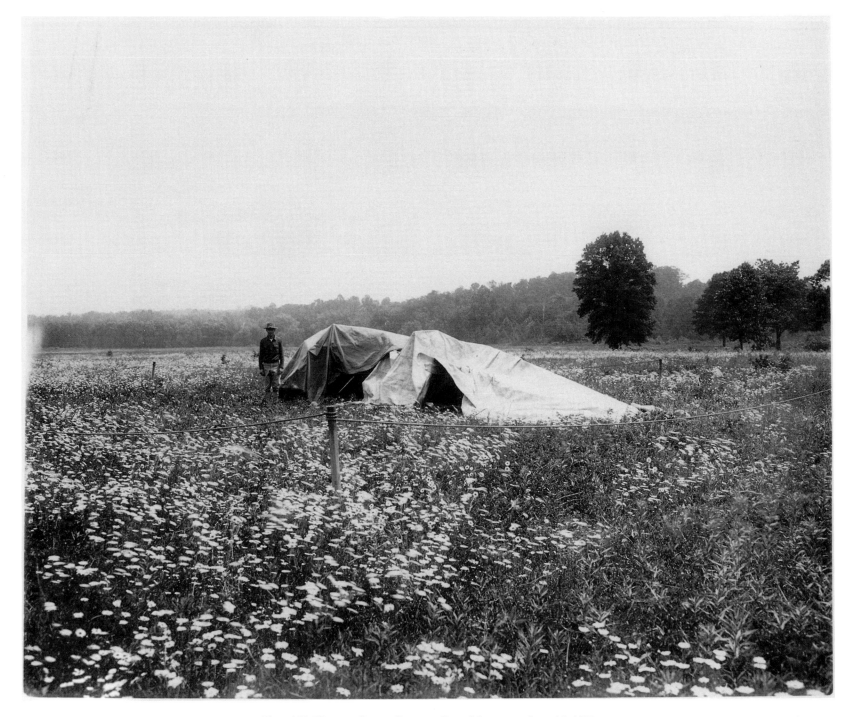

Plate 107. WELSH'S CRASH, COLLEGE PARK, MARYLAND, JUNE 11, 1912

Arthur Welsh, Wright Company exhibition pilot, and Lt. Leighton W. Hazelhurst were killed while
conducting official army acceptance tests of the Wright Type C, M-1 airplane.

Photographer Unknown

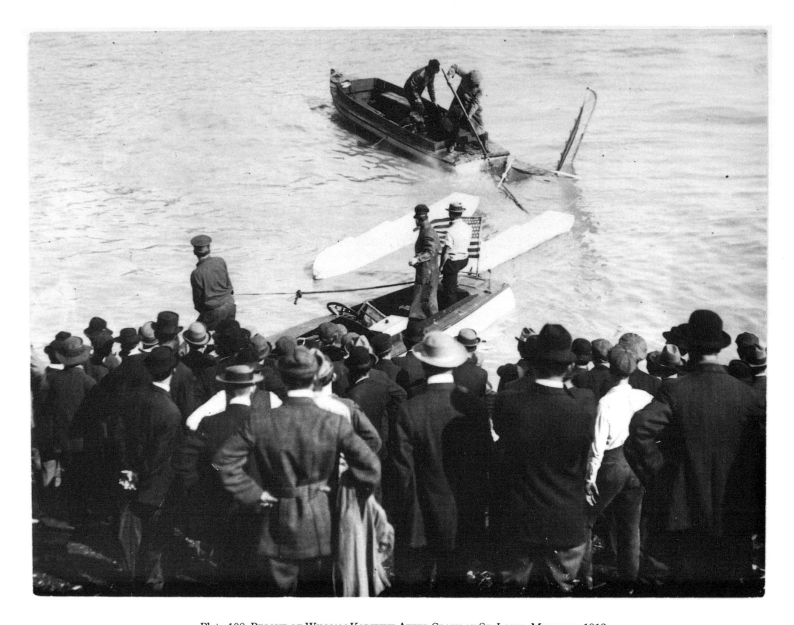

Plate 108. Rescue of William Kabitzke After Crash at St. Louis, Missouri, 1912

"If you are not successful in the project you now have on hand, I think it quite probable that we could give you some employment in our shop, with the prospect of doing some flying from time to time. If you would be interested in such employment, we would be glad to have you come down to Dayton at your convenience to talk over the matter" Orville Wright to William Kabitzke, June 19, 1912.

Photographer Unknown

Plate 109. R. G. FOWLER IN HIS WRIGHT MODEL B, 1911

Newspaper mogul William Randolph Hearst offered a $50,000 prize for the first coast-to-coast flight made in thirty days or less. Robert G. Fowler, a Wright-trained pilot, left San Francisco on September 11, 1911, to claim the reward. After his Model B failed to clear the Sierra Nevada, he started again from Los Angeles. He finally arrived in Jacksonville, Florida on February 8, 1912, 112 days after leaving the West Coast and eighteen weeks after the Hearst offer had expired.

Photographer Unknown

Plate 110. RETURN TO KITTY HAWK, OCTOBER 1911

This is the scene that greeted Orville, his brother Lorin Wright, nephew Horace Wright, and
Englishman Alec Ogilvie when they returned to Kitty Hawk. During their stay October 10-30, 1911,
Orville made more than ninety glides and established a world soaring record of nine minutes,
forty-five seconds, which stood for ten years.

Wright Photograph

140

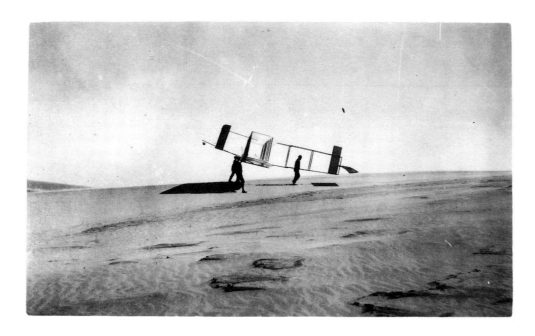

Plate 111. CARRYING THE GLIDER AT KITTY HAWK, 1911

"Flying in a 25-meter-per-second wind is no snap, and I can tell you that it keeps one pretty busy with the levers. I got caught in one whirl of wind that turned my machine completely around and drove me into the hill. I didn't receive a scratch but the machine needed the doctor pretty badly. I found that in order to fly in such winds a greater control than has ever been put on any power machine would be necessary. It was not the velocity of the wind, but its sudden changes in direction that made the flying difficult" Orville Wright to Captain Thomas S. Baldwin, November 19, 1911.

Wright Photograph

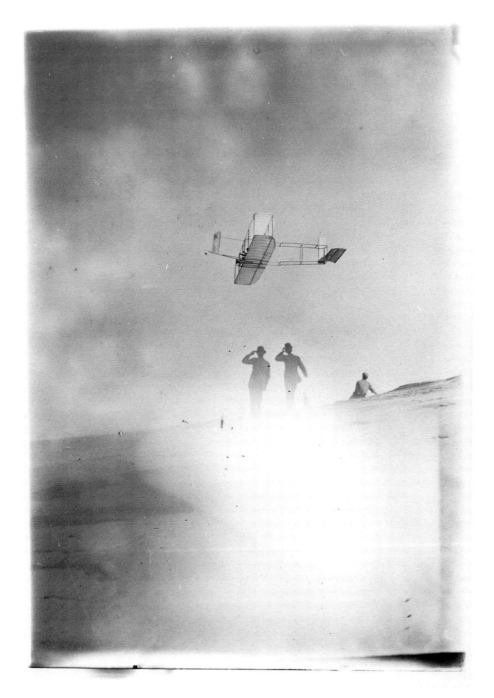

Plate 112.
ORVILLE SOARING AT
KITTY HAWK, 1911

"In regard to the experiments which I lately made in soaring flight, in many of which flights I remained in the air for periods of three to five minutes, and for one flight for a space of nine and three-quarters minutes, I will say that this kind of flight, though never before achieved by man, is very common with birds. . . .A better knowledge of these air currents, so that one could keep his machine constantly in the rising trends, would enable one to remain aloft without power much longer than has yet been done" Orville Wright to J. A. Heringa, November 18, 1911.

Wright Photograph

Plate 113. WRIGHT COMPANY CATALOG, CA. 1912

The Wright Company was incorporated on November 22, 1909, with a capital stock of $1 million, with Wilbur as president and Orville as vice-president. On October 15, 1915, Orville sold the company to a syndicate of financiers, citing his poor health and desire to devote his time to scientific research.

CORNER OF SEWING DEPARTMENT

Plate 114. IDA HOLGROVE WORKING IN THE SEWING DEPARTMENT OF THE WRIGHT COMPANY FACTORY, DAYTON, 1911

Wright Company Photograph

CORNER OF PAINT SHOP

Plate 115. MR. STEINWAY AND HARRY HAROLD IN THE PAINT SHOP OF THE DAYTON FACTORY, 1911

Wright Company Photograph

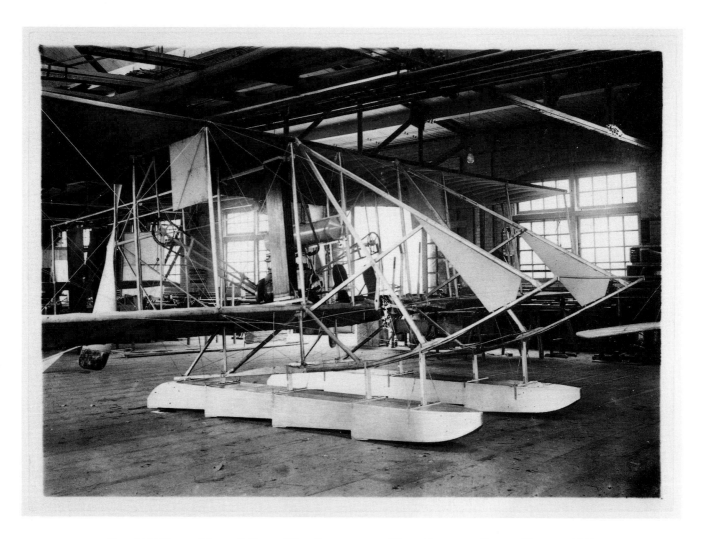

Plate 116. Wright Model B Fitted With Pontoons for Water Landings, Dayton Factory, 1913

Orville experimented with hydroplanes on the Great Miami River near Dayton in May and June 1913. In July the Wright Company announced the manufacture and sale of the model CH seaplane.

Wright photograph

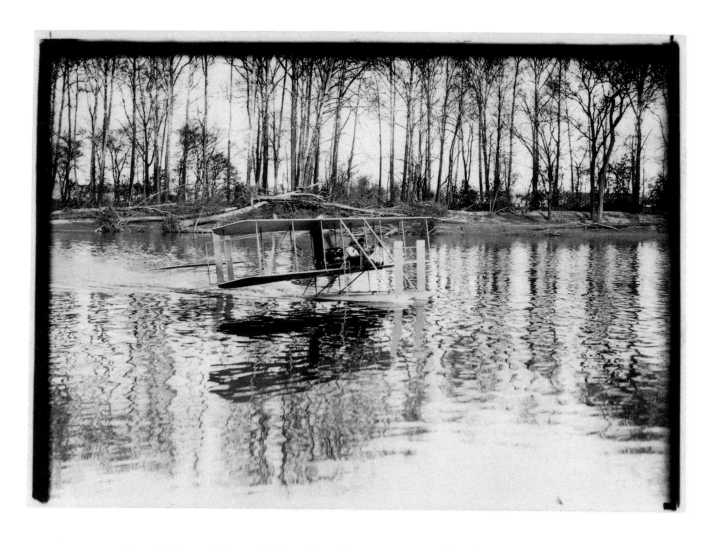

Plate 117. ORVILLE TESTING A MODEL B AS A HYDROPLANE ON THE GREAT MIAMI RIVER, MAY 1913

"The past several weeks I have been experimenting on the river near Dayton with a pontoon which is easily attached to any of our machines. . . .The river where we were experimenting is only three or four hundred feet wide so that the water is perfectly smooth. We are contemplating testing out this same pontoon on one of the reservoirs in the northern part of the state, where we will be able to learn its action in waves" Orville Wright to Captain Holden C. Richardson, June 18, 1913.

W. Preston Mayfield, staff photographer, Dayton News

Plate 118. Model B Hydroplane in Flight Over the Great Miami River, May 1913

W. Preston Mayfield, staff photographer, Dayton News

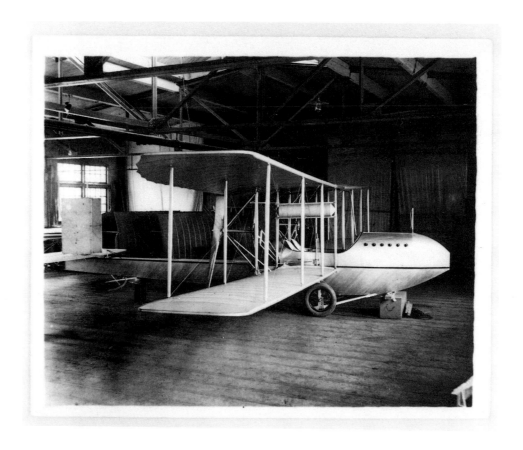

Plate 119. WRIGHT MODEL F, DAYTON, CA. 1913-14

The model F, delivered to the army in 1914, was the first Wright machine with a
fuselage. It was also the first Wright plane to place the vertical rudder above the elevator
and the first to use tractor instead of pusher-type propellers.

Wright Company photograph

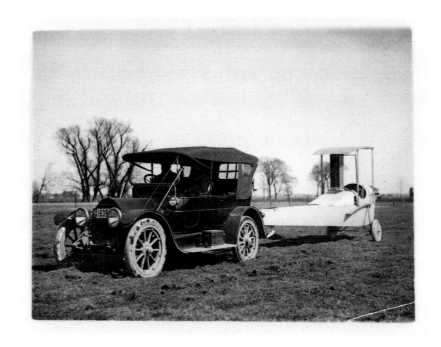

Plate 120. Wright Model F Being Towed by an Automobile,
Dayton, ca. 1913-14

Wright Company Photograph

THE LONG TWILIGHT

---◆---

WILBUR WRIGHT'S PREMATURE death in 1912 was an incalculable loss to aviation. What the Wright brothers had achieved, they had achieved together. With Wilbur's death, Orville continued on alone, but he never ceased to miss his brother. We can only speculate on what the two of them together might have accomplished in those later years.

In the years immediately after Wilbur's death, Orville used his energies on two innovations: the automatic stabilizer and the hydroplane. Automatic stability had been a long-sought goal of many aeronauts. Orville hoped to free pilots from the constant and tiresome vigilance needed to maintain equilibrium in flight. Starting in December 1912 and continuing into 1913, he worked at perfecting such a device. The Wright automatic stabilizer used a pendulum and a vane. The pendulum was connected to a battery so that whenever it swung out of the vertical, the wing warping control was activated to restore balance. A horizontal vane provided fore-and-aft control by activating the elevator when the aircraft deviated from the prescribed course.

Through the fall of 1913, Orville tested this device at the old flying field at Huffman Prairie. Finally, on December 31, 1913, he demonstrated it before a panel of judges from the Aero Club of America. At the climax of the demonstration, he made seven complete circles of the field with his hands entirely off the controls. The Aero Club awarded him the Collier Trophy for 1913 for the most significant contribution to aeronautics in that year.

Also in 1913, Orville developed and tested hydroplanes and pontoons to allow Wright Flyers to take off and land on water. Using the Great Miami River south

Plate 121. ORVILLE AND KATHARINE ON THE PORCH AT HAWTHORN HILL,
THE WRIGHT MANSION NEAR DAYTON, CA. 1920

The seventeen-acre tract for this house in the Dayton suburb of Oakwood was
purchased in 1910, and the house was completed after Wilbur's death. Orville, Katharine,
and Bishop Milton Wright moved into the home April 28, 1914.
Orville lived there until his death on January 30, 1948.

Wright Photograph

of Dayton as a testing site, he waded out into the river to adjust the pontoons before flights. By the late summer, the Wright Company was advertising and selling flying boats.

The patent suits that had so bedeviled Wilbur continued. The Curtiss people persuaded the Smithsonian Institution to take the old Langley Aerodrome out of storage, refurbish it, and demonstrate that it was capable of flight. The purpose, of course, was to diminish the viability of the Wright patent by showing that the Wright Flyer had had an earlier competitor. In June 1915, heavily modified and reinforced, the Aerodrome did indeed make several short flights at Hammondsport, New York. This use of a museum artifact to further a competitor's lawsuit infuriated Orville Wright and led to a break with the Smithsonian Institution. Some years later, when approached to donate the 1903 Kitty Hawk plane to the national museum, Orville refused unless the Smithsonian apologized for its use of the Langley machine and also changed the label crediting the Aerodrome as the first machine capable of flight. In 1928 Orville sent the Kitty Hawk Flyer to England to be displayed at the London Science Museum. It was not returned to America until after the Second World War, when the Smithsonian finally satisfied Orville's conditions.

The entry of the United States into World War I in April 1917 made a resolution of the patent disputes mandatory. The government directed all parties to form the Manufacturers Aircraft Association, which bought up all patent rights and made them available to all licensed manufacturers.

By then, Orville was out of the aircraft business. Never fond of management, shy and retiring by nature, he had long sought relief from business affairs. On October

Plate 122. AERIAL VIEW OF HAWTHORN HILL

Following Orville's death, the mansion was purchased by the National Cash Register Company
and is presently used as a corporate guest house.

Photographer Unknown

15, 1915, he had sold the Wright Company to a syndicate of financiers for a settlement that made him a millionaire and enabled him to retire to a life of research and study.

He built himself a private research laboratory at 15 North Broadway in Dayton and there, at the Wright Aeronautical Laboratory, he spent much of the rest of his life in fundamental, although not terribly productive, research. He was soon appointed to the National Advisory Committee for Aeronautics and assumed the role of senior statesman of aviation. Orville hosted distinguished aeronautical visitors to Dayton, such as Charles Lindbergh; he put in obligatory appearances at aviation dinners and events; and he was often interviewed by the newspapers on aeronautical developments.

His tranquil life was disturbed in 1926 when his sister Katharine, who had acted as his companion and hostess at Hawthorn Hill, decided to marry her old college friend Henry Haskell, the editor of the Kansas City *Star*. Orville was devastated at Katharine's defection, cut all ties with her, and only reluctantly agreed to travel to Kansas in 1929, as she lay dying, to bid her farewell.

Orville died in Dayton on January 30, 1948, of a massive heart attack. He had outlived Wilbur by thirty-six years, long enough to see the airplane cease to be an experimental object and a rich man's toy and become the principal tool for achieving victory in World War II, acknowledged by all as one of the most important inventions of the twentieth century.

The discovery of the secrets of flight was a supreme achievement. Together, Wilbur and Orville accomplished what they had set out to do, and more. As long as human beings fly. . . .wherever they journey through space. . . .their flights begin with Wilbur and Orville Wright.

Plate 123. ORVILLE AND SCIPIO AT LAMBERT ISLAND, CANADA, CA. 1925

Orville acquired Scipio, a Saint Bernard, on March 10, 1917, and the dog was his
inseparable companion for many years. Orville purchased Lambert Island, in Georgian Bay,
Canada, in 1916. He spent his summers on the island until after the Second World War.

Wright Photograph

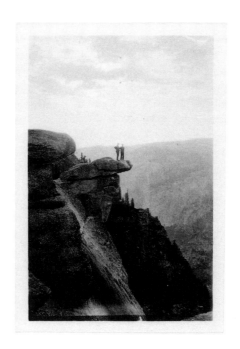

Plate 124. TAKEN DURING ORVILLE'S TRIP OUT WEST, JULY 1919

Orville and a group of close friends and colleagues took a month-long auto trip to the
West Coast, July-August 1919. Col. Edward A. Deeds was the group leader. They made
stops in Denver, Salt Lake City, Reno, San Francisco, and Los Angeles.

Wright Photograph

"Oh Wright's" smile began at sunrise

Plate 125. "OH WRIGHT'S SMILE BEGAN AT SUNRISE," TAKEN DURING THE WESTERN TRIP, 1919

From the album of Col. Edward A. Deeds

Plate 126. U. S. Airmail Stamp Issued on December 17, 1978, to Commemorate the
Seventy-Fifth Anniversary of the First Flight

ABOUT THE AUTHORS

RONALD R. GEIBERT is a nationally exhibited artist with more than 100 shows to his credit. His work can be found in permanent collections, including those at the Museum of Modern Art in New York City, the New Orleans Museum of Art, and the Corcoran Gallery of Art and the Library of Congress, both in Washington, D. C. In 1984 he was the co-author of a book and curator of a Smithsonian Institution touring exhibition both entitled *Early Flight: 1900-1911.* The following year he produced a critically acclaimed limited edition photographic portfolio under the same title.

An associate professor of art at Wright State University in Dayton, Ohio, Geibert created the limited edition portfolios *Nebraska Fairs, Competitions, Parades,* and *Mardi Gras.* He also organized an exhibition on the Farm Security Administration period, has written articles for exhibition catalogues and a Polaroid Corporation teaching manual, and has received numerous grants.

Currently he is serving as the principal investigator for a forthcoming Smithsonian Institution exhibition examining competition in the lives of American and Japanese children.

PATRICK B. NOLAN received his B.A. from Carleton College, Northfield, Minnesota, in 1964 and his Ph.D. in American history from the University of Minnesota in 1971. He then joined the History Department of the University of Wisconsin-River Falls, where he taught and administered a regional history research archive. In 1973 he became the head of Archives and Special Collections and associate professor of history at Wright State University in Dayton, Ohio. There he developed a nationally recognized program in public history, directed a center for early aviation studies, and helped to restore an original Wright Brothers bicycle shop.

In 1988 he was appointed executive administrator of the Center for the History of Business, Technology, and Society of the Hagley Museum and Library in Wilmington, Delaware. He has published *The Wright Brothers Collection: A Guide to the Technical, Business and Legal, Genealogical, Photographic, and Other Archives at Wright State University* (1977), *Vigilantes on the Middle Border: A Study of Self-Appointed Law Enforcement in the States of the Upper Mississippi from 1840 to 1880* (1987), and *Keeping the Promise: A Pictorial History of the Miami Conservancy District* (1988).

WRIGHT

FLYERS